Painting with Light

PHOTOGRAPHY AT THE FREER|SACKLER

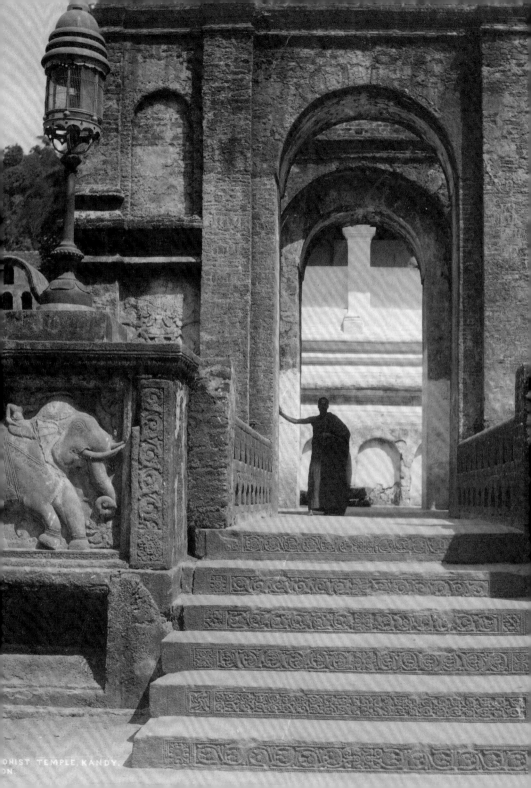

Painting with Light

PHOTOGRAPHY AT THE FREER|SACKLER

g
GILES

FREER | SACKLER

The Smithsonian's Museum of Asian Art,
Washington, DC

Published by Freer|Sackler, the Smithsonian's museum of Asian art:
asia.si.edu

Distributed in the USA and Canada by
Consortium Book Sales & Distribution
The Keg House
34 Thirteenth Avenue, NE, Suite 101
Minneapolis, MN 55413-1007
USA
www.cbsd.com

GILES
An imprint of D Giles Limited
4 Crescent Stables
139 Upper Richmond Road
London
SW15 2TN
UK
www.gilesltd.com

Frontispiece: Entrance to Buddhist temple; Scowen and Co. (act. 1870–90); Kandy, Sri Lanka, after 1876; albumen print, 21.5 × 27.7 cm; Charles Lang Freer Papers, Freer|Sackler Archives

Editors: Jane Lusaka and Joelle Seligson
Designer: Adina Brosnan McGee

Library of Congress Cataloging-in-Publication Data

Names: Freer Gallery of Art, author. | Arthur M. Sackler Gallery
(Smithsonian Institution), author.
Title: Painting with light : photography at the Freer/Sackler, the
 Smithsonian's Museum of Asian Art, Washington, D.C.
Description: Washington, D.C. : Freer/Sackler, the Smithsonian's museum
of Asian art, 2017. | Includes bibliographical references and index.
Identifiers: LCCN 2016034941 | ISBN 9781907804656 (pbk.)
Subjects: LCSH: Freer Gallery of Art. | Arthur M. Sackler Gallery
 (Smithsonian Institution) | Asia--Pictorial works. |
 Photography--History--19th century. | Photography--History--20th
century.
 | Photography--History--21st century. | Photography--Washington
(D.C.)
Classification: LCC DS5.5 .F74 2017 | DDC 779.074/753--dc23 LC record
available at https://lccn.loc.gov/2016034941

Typeset in Benton Sans
Printed and bound in China

Contents

1 Introduction

9 Looking the Part

77 A Sense of Place

149 Witness: Tokyo to Tehran

208 Endnotes

208 About the Authors

209 Index

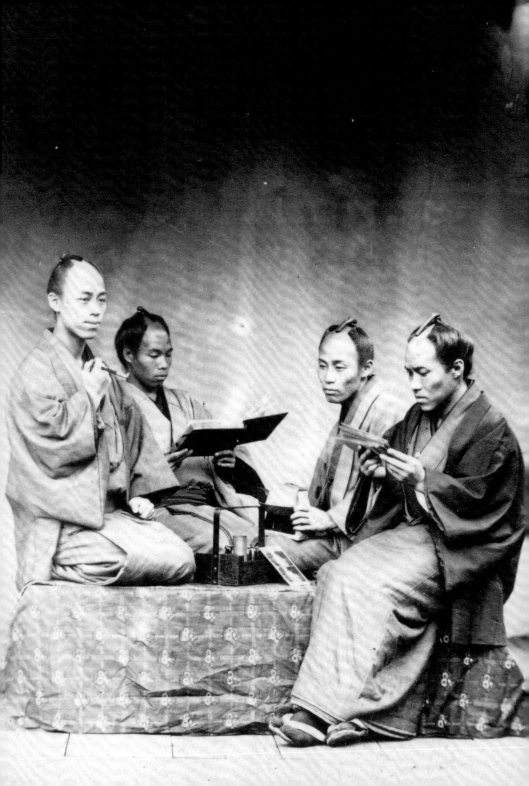

Introduction

Just months after the word *photography* was coined in 1839, the new technology had spread across the world. Europeans and Americans initially dominated the photography trade and its stylistic conventions, largely due to the overwhelming logistical advantages that Westerners enjoyed. Yet the medium was quickly adopted throughout Asia and the Middle East, resulting in an enormous body of images that have profoundly shaped visual culture and art from the nineteenth century to the present. While not encyclopedic in scope, the Freer|Sackler collections illustrate trends in photography's evolution—in particular, how photographs have formed perceptions in and of Asia and the Middle East.

Photographs came to the collections of the Freer|Sackler, the Smithsonian's museum of Asian art, primarily by accident. Having made his fortune in the railroad industry, museum founder Charles Lang Freer (1854–1919) began to cautiously collect art in the 1880s, beginning with American and European works. As his range expanded to include East Asian, Southeast Asian, Indian, and Middle Eastern artworks, so did his interest in the cultures that produced them. Between 1895 and 1911, he traveled to Asia and the Middle East repeatedly.

Like numerous scholars and collectors of the time, Freer began his photography collection mostly with shots of the artworks and architectural monuments that interested him, as well as with mementos from his extensive voyages. While Freer never considered photography part of his collecting scope, it is clear that his interest in and appreciation of photography deepened throughout his life. His evolving regard for the medium also reflects the increasing acceptance in the early twentieth century of photography as a legitimate art form, rather than as simply a mechanical recording instrument.

I
Looking at Photographs
Unknown photographer
Japan, ca. 1860s
Albumen carte de visite,
9.6 × 6 cm
Henry and Nancy Rosin
Collection
Freer|Sackler Archives

The photographs that he accumulated represent an impressive array of production by studios in the United States and across Asia. These images were not among the more than twenty thousand works of art that Freer gave to the Smithsonian in 1906. After he died in 1919, however, many of Freer's personal effects were also transferred to his forthcoming museum in Washington, DC, including more than two

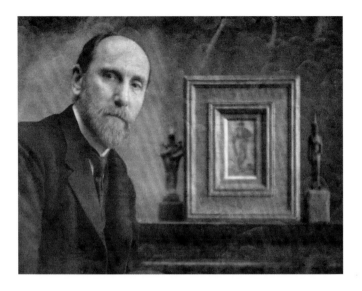

thousand photographic prints and negatives. Following the opening of the Freer Gallery of Art in 1923, many of the founder's photographs were made available to curators and visiting scholars as part of the museum library's reference collection. Such materials were especially useful at a time when access to significant visual resources for art historical study was considered a luxury.

Over the years, a great deal of Freer's prints were lost or discarded. The first task of the Freer|Sackler Archives, which was formally established when the Arthur M. Sackler Gallery opened in 1987, was to gather and inventory Freer's papers, including what remained of his photographs. While the photographs in the Charles Lang Freer Papers form an important group, in the last few decades the Archives has acquired a range of other collections. Among its more than 125,000 photographic items are numerous important examples from across Asia, the Middle East, and North Africa, ranging from salt prints of the 1850s to autochromes of the early twentieth century. Particularly notable holdings include the Henry and Nancy Rosin collection of photographs of nineteenth-century Japan, archaeologist Ernst Herzfeld's papers, and the largest collection outside of Iran of Antoin Sevruguin's glass plate negatives and prints.

II
Charles Lang Freer
Alvin Langdon Coburn
(1882–1966)
Detroit, United States,
1908
Autochrome, 10 × 8 cm
Charles Lang Freer
Papers
Freer|Sackler Archives

III
Portrait of Charles Lang Freer
Edward Steichen
(1879–1973)
United States, 1915–16
Platinum print,
27 × 22 cm
Charles Lang Freer
Papers
Freer|Sackler Archives

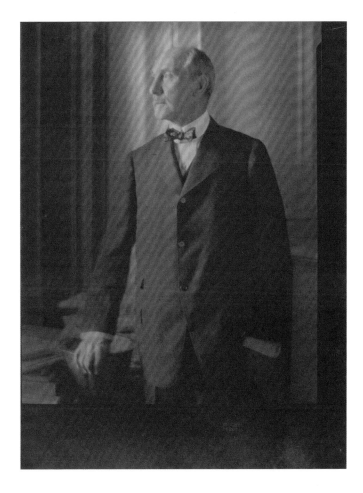

Since the late 1990s, the Freer|Sackler's collection of modern and contemporary photography has been building on the strength of the Archives and expanding into new areas of artistic practice. The museum's holdings have steadily grown to some four hundred later twentieth- and twenty-first-century works from Iran, Japan, and India, as well as the Republic of Korea, China, Vietnam, Kuwait, and Saudi Arabia, among other locales. The artists who created these images work within and across the fluid genres of portraiture, landscape, and social documentary. In its entirety, the collection offers a glimpse

of the ways in which artists have been speaking to the history of photography, radically experimenting with format and techniques, and enriching the medium's conceptual possibilities.

A selection from the collections is presented in this volume. From archival to contemporary, these works trace continuities and contrasts over nearly two hundred years of photography. As photography progresses into its third century, the Freer|Sackler continues to expand this important resource for studying specific historical, cultural, and artistic contexts, as well as broader thematic developments seen across cultures.

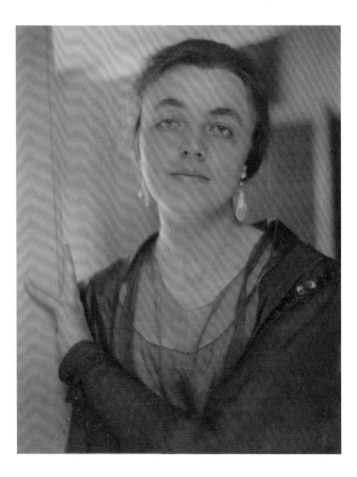

IV
Katharine Nash Rhoades
Alfred Stieglitz
(1864–1946)
United States, 1915
Platinum print,
25.5 × 20 cm
Charles Lang Freer
Papers
Freer|Sackler Archives

Freer's Brush with the Avant-Garde

Freer's friendship with the pioneering art photographer Edward Steichen seems to have lasted from 1915 to 1917. Freer's diaries record frequent dinners, theater visits, and scenic travel with the younger man, who had Freer sit for multiple studio sessions. The two men likely had much in common: critics had often compared Steichen's earlier work to the compositional and tonal qualities of the paintings of American artist James McNeill Whistler, to whom Freer was devoted.

Katharine Nash Rhoades (1885–1965), Freer's personal assistant, also was a painter. Her work was included in the famous New York Armory Show of 1913, and she was a member of the clique of American artists associated with the 291 Gallery, a hub of avant-garde discourse and visual expression. Alfred Stieglitz, who created and managed 291, was also a friend to Edward Steichen and a major figure in the elevation of American photography as an art form. In his portrait of Rhoades (fig. IV), Stieglitz displays the same delicate sensitivities that would later find their finest expression in his numerous portraits of the artist Georgia O'Keeffe.

In Freer's final years, Rhoades became his constant companion and was a major factor in his aesthetic formulation of the Freer Gallery of Art. Freer did not seem to have much direct contact with Stieglitz. That this portrait ended up in Freer's possession speaks to Rhoades' ongoing intermediary role in bringing him in contact with artistic societies.

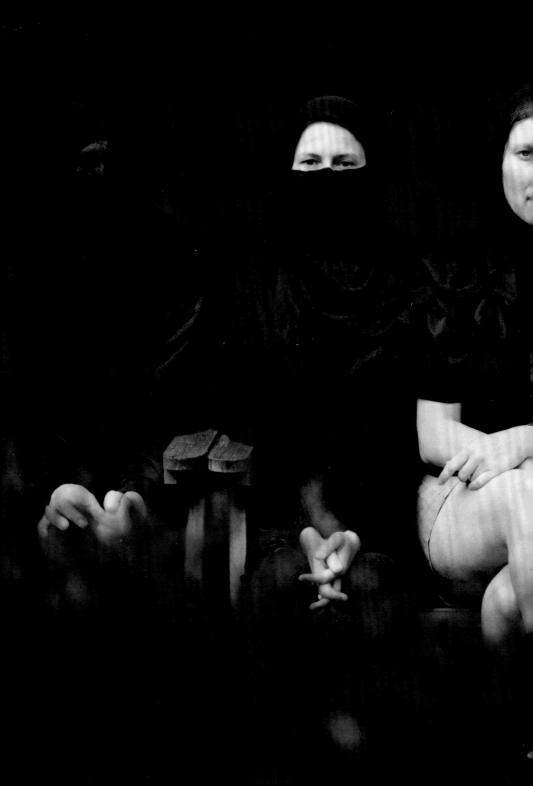

Looking the Part

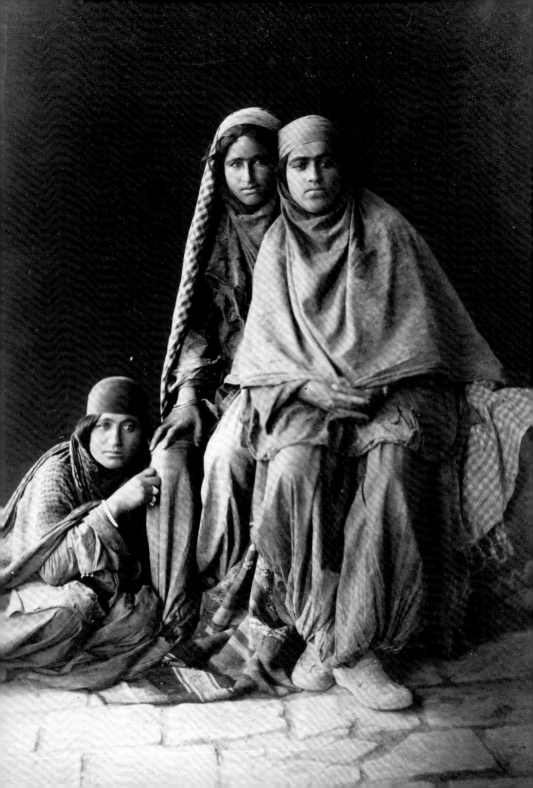

The enduring power of the portrait photograph to shape perceptions of Asia is a theme that runs through the Freer|Sackler collections. Among the earliest examples are photographic portraits by a motley mix of European and American military officers, explorers, and adventurous entrepreneurs. Coinciding with the high-water mark of the colonial enterprise, many early photographers saw Asia and the Middle East as subjects to be captured according to Western stylistic conventions. Their images fed a Western audience eager for images of faraway and so-called exotic places and people—or they served to classify populations and control colonial territories.

Many of the first studios in Asia and the Middle East were established by Westerners who could afford to purchase limited supplies of chemicals and expensive photographic equipment. For example, the German photographer August Sachtler and the British-Italian photographer Felice Beato produced some of the earliest and most compelling portraits taken in Japan. They and other European photographers, however, soon had to compete with their Japanese counterparts, such as Suzuki Shinichi I, who became known for his imaginative genre and historical recreations. By the late nineteenth century, numerous local photographers were establishing their own professional studios, focused primarily on developing a clientele in their own regions and countries.

Patronage by the wealthy and political elite also accelerated the integration of photographic portraiture into daily life during the nineteenth century. Early on, the mass dissemination of royal portraits was recognized as an effective tool for legitimizing authority both within and beyond national borders. Suzuki's photos of the imperial family were meant to show that Japan could stand on an equal footing with the great powers on the world stage. Similarly, in China, the empress dowager Cixi used photography to cast off traditions of imperial seclusion and meet Western standards of diplomatic protocol. Photographer Antoin Sevruguin, benefitting from extraordinary access to the royal court in Iran, captured informal views of court life, as well as surveys of the outlying regions.

Since the mid-twentieth century, a number of artists have found inspiration in the historical development and archival richness of

1
previous spread
Untitled I
Jananne Al-Ani
(b. 1966, Iraq)
1996
Color photographic print from black-and-white internegative,
132.7 × 185.4 cm
Purchase—Arthur M. Sackler Gallery,
S1998.112.1

2
facing page
Three Women
Antoin Sevruguin
(d. 1933)
Iran, ca. 1880
Albumen print
13.1 × 20.3 cm
Stephen Arpee Album, Freer|Sackler Archives

portrait photography. Moving beyond traditional efforts to capture and enhance likenesses for commercial, ethnographic, or political purposes, modern and contemporary artists from Asia have been exploring the cultural and psychological dimensions of the portrait photograph. Bahman Jalali and Malekeh Nayiny reanimate archival images to connect with lost individuals and memories. Shadafarin Ghadirian and Jananne Al-Ani reinterpret the conventions of studio portraiture to challenge the representation of women. Self-portraits by Pamela Singh and Pushpamala N. reference painting traditions and color as a way of probing photography's capacity to convey social and personal identity.

Venturing out of the studio and into India's dusty landscape, one encounters the subjects of Gauri Gill's work and the intricate relationships among photographer, individual, and place. Further pushing the boundaries of portrait photography, Suh Do-Ho takes a more abstract approach to convey the tenuous link between place and identity. The works of Mitra Tabrizian and Tarek Al-Ghoussein are imbued with the sense of dislocation and loss that pervades the social and psychological state of the exile. In both content and format, this selection of contemporary photographs in the Freer|Sackler collections offers compelling examples of how artists continue to reinterpret the genre.

3
Raami
From the series
Balika Mela
Gauri Gill
(b. 1970, India)
2003–10
Inkjet print, 160 ×
106.7 cm
Purchase—Friends of
the Freer and Sackler
Galleries
Arthur M. Sackler
Gallery, S2013.7

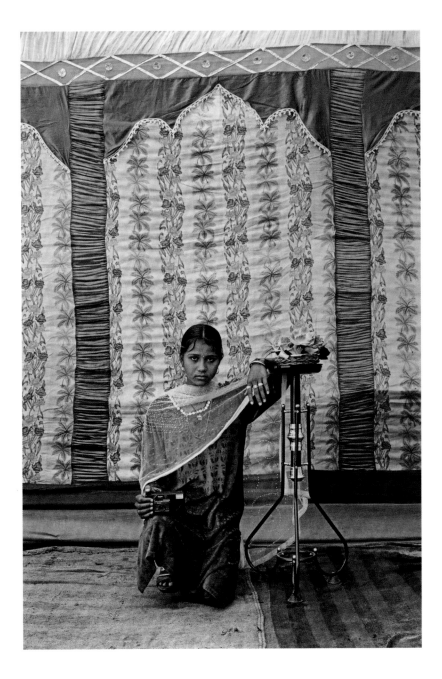

The People of India was one of the first ethnographic studies produced with a camera. Compiled between 1868 and 1875, the eight volumes contain 468 photographs taken by British army officers, administrators, and amateur photographers and repurposed as illustrations of races and tribes of South Asia. The project was an early demonstration of what would become a trend: appropriating commercial, "picturesque" images of people into surveys of "typical native types," thereby reinforcing stereotypes relating to race, criminality, and appearance. The selections of photographs and their accompanying texts in The People of India were influenced further by regional and ethnic loyalties during the Indian Mutiny against the British in 1857. Accordingly, the volumes speak more to colonial apprehensions and military exigencies than to actual ethnic groups.

4–7
this page
and the following
spread from
*The People of
India: A Series
of Photographic
Illustrations,
with Descriptive
Letterpress, of the
Races and Tribes
of Hindustan.*
Edited by J. Forbes
Watson and John
William Kaye.
London: India
Museum, 1868
Freer|Sackler
Archives

WUZEERUN.
BAZAR WOMAN.
MAHOMEDAN.
SAHARUNPOOR.
(165)

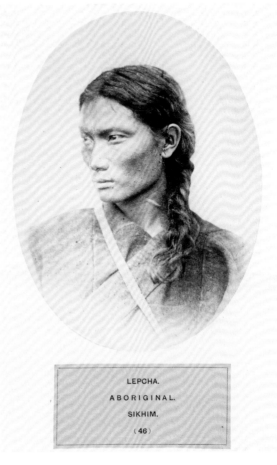

LEPCHA.
ABORIGINAL.
SIKHIM.
(46)

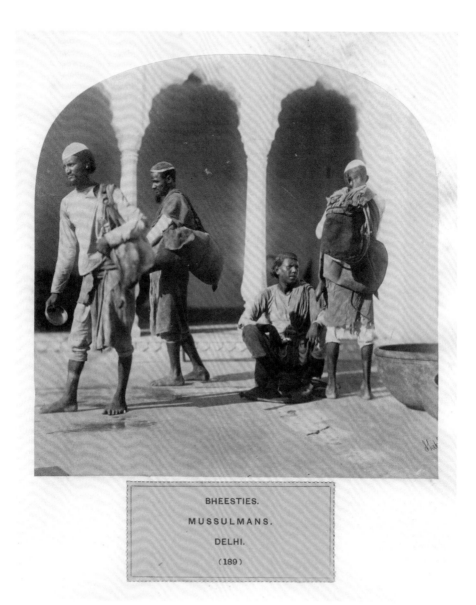

BHEESTIES.

MUSSULMANS.

DELHI.

(189)

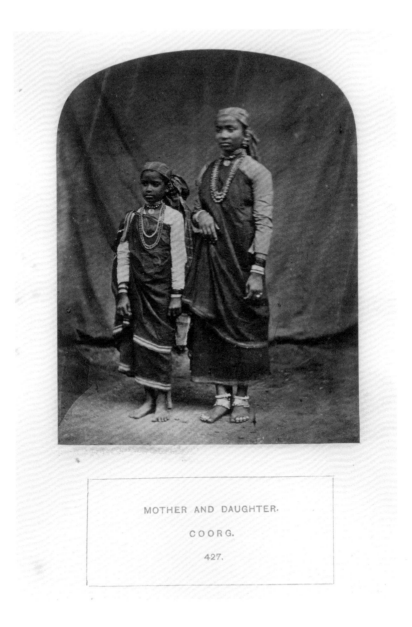

MOTHER AND DAUGHTER.

COORG.

427.

German-born **August Sachtler** (died 1874) is one of several early photographers who fell into the profession. While accompanying a Prussian naval expedition to Japan as a telegraph operator in 1860–61, he was asked to assist the staff photographer, whose technical skills were lacking. Sachtler, however, excelled at the craft, producing some of the earliest and most compelling portraits of Japan.

The tourist photography trade in Japan gradually gave way to local competitors vying to attract growing streams of sightseers. Master photographer Shimooka Renjō (1823–1914) in Yokohama, for example, went to extraordinary lengths to master the chemical processes of photography, often with almost no technical guidance. Other Japanese artists hand-painted albumen prints with delicate colors and mounted them in attractive lacquer-covered albums, which became requisite souvenirs; many prints made their way to American and European homes.

Constant competition and the cycle of new studios replacing failed enterprises led to a rapid exchange of images. New companies either bought older stocks of negatives or simply copied other studios' best-selling images for their own portfolios, making it difficult to track the true attribution for many early images. This print of a Japanese official, for instance, was only recently identified as (most likely) the work of Sachtler.

8
Japanese official
Attributed to August Sachtler (d. 1874)
Japan, 1861
Albumen print,
19.3 × 14.4 cm
Purchase,
Freer|Sackler
Archives

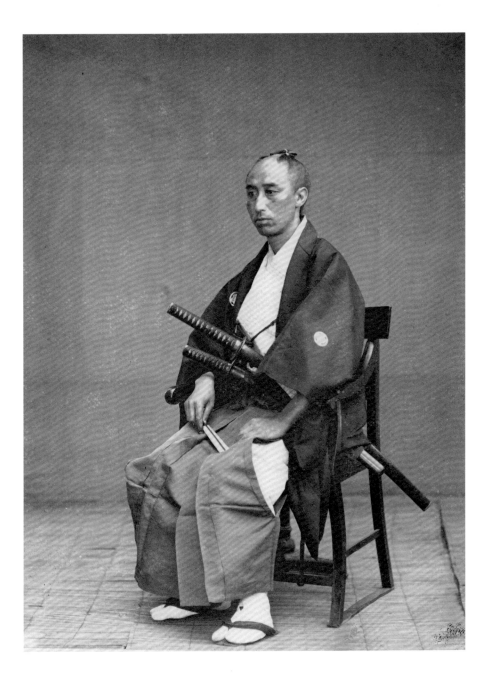

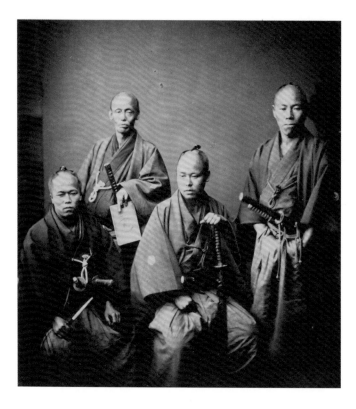

9
Satsuma Clan Envoys
Felice Beato
(1832–1909)
Japan, 1863
Albumen print
mounted on album
page, 16.8 × 15.3 cm
Henry and Nancy
Rosin Collection of
Early Photography
of Japan
Freer|Sackler
Archives

10
Woman with gold obi
Unknown
photographer
Japan, 1860–ca. 1900
Hand-tinted
mammoth plate,
52.2 × 41 cm
Henry and Nancy
Rosin Collection of
Early Photography
of Japan
Freer|Sackler
Archives

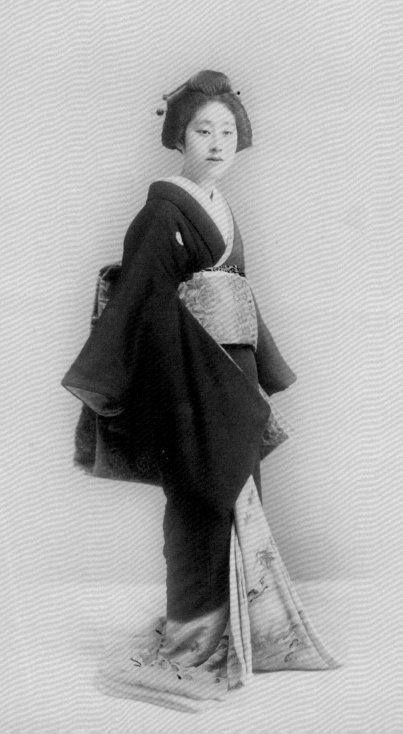

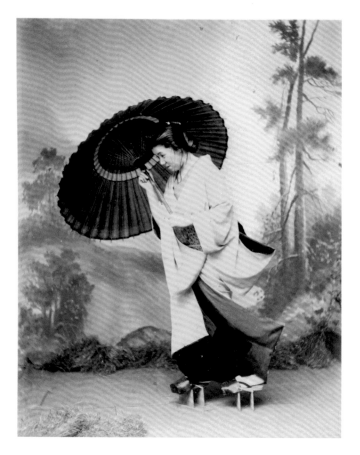

11
Woman with umbrella in the wind
Unknown photographer
Japan, 1860–ca. 1900
Hand-tinted albumen print, 24.1 × 19.2 cm
Henry and Nancy Rosin Collection of Early Photography of Japan
Freer|Sackler Archives

12
Woman at toilette
Unknown photographer
Japan, 1860–ca. 1900
Hand-tinted albumen print, 25.9 × 20.5 cm
Henry and Nancy Rosin Collection of Early Photography of Japan
Freer|Sackler Archives

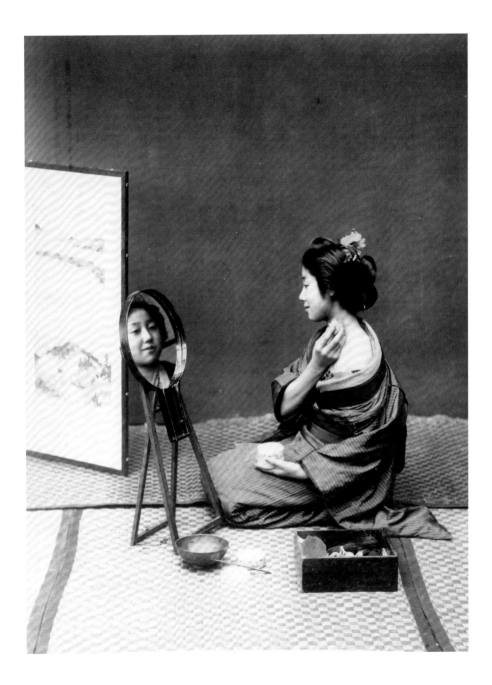

Suzuki Shinichi I (1835–1918) established a studio in Yokohama in the 1870s after apprenticing under Shimooka Renjō, one of the first professional Japanese studio photographers. In 1872, the Scottish writer and publisher J. R. Black asked Suzuki to supply photographic illustrations for *The Far East*, a short-lived but tremendously influential English-language journal presenting news, history, and culture about East Asia. Typically created under tight deadlines, Suzuki's images often depict genre or historical settings.

In 1889, Suzuki and **Maruki Riyō** (1854–1923) were commissioned by the imperial court to photograph Japan's emperor and empress. The Japanese were intent on proving their ability to stand on an equal footing with the world's great powers. The images were therefore designed to show an enlightened but resolute ruler in Western military garb, with an empress in a splendid gown suitable for European courts and almost no trace of Japanese costume or decoration. The portrait of the emperor is actually a photograph of a drawing; the emperor disliked being photographed, so much so that when his aides saw the need for an updated official portrait, they hired an Italian artist to sketch his likeness from behind a screen.

Alice Roosevelt Longworth visited Japan with a US delegation, led by then-Secretary of War William Howard Taft, in July 1905. To mark the occasion, the Japanese court presented her with two of these portraits. Elaborate wooden frames were made specially for this set of images bearing the personal signatures of the emperor and empress—a remarkably intimate gift for the daughter of the American president.

13
Plant Seller
Suzuki Shinichi
(1835–1918)
Japan, ca. 1872
Albumen print,
14.2 × 18.2 cm
Henry and Nancy
Rosin Collection of
Early Photography
of Japan
Freer|Sackler
Archives

14
Doctor and Patient
Suzuki Shinichi
(1835–1918)
Japan, ca. 1872
Hand-tinted albumen
print, 13.5 × 17.5 cm
Henry and Nancy
Rosin Collection of
Early Photography
of Japan
Freer|Sackler
Archives

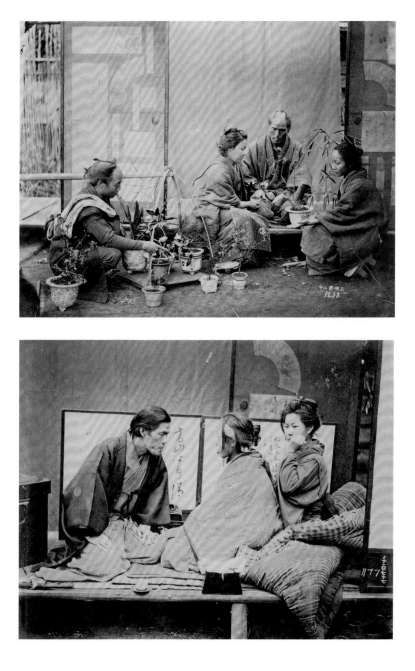

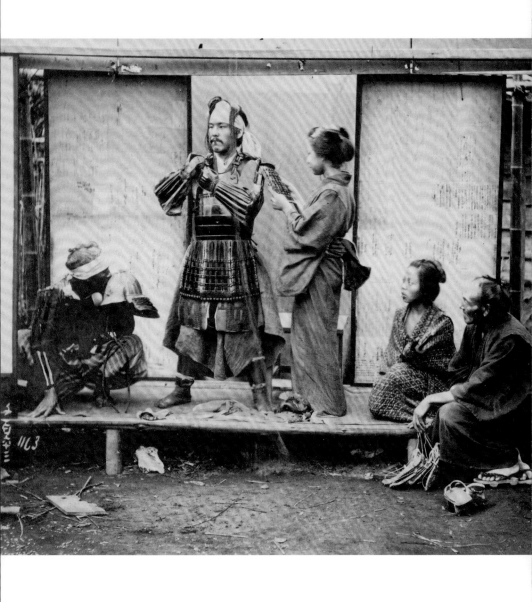

15
Putting on Armor
Suzuki Shinichi
(1835–1918)
Japan, ca. 1872
Hand-tinted albumen
print, 13.7 × 17.6 cm
Henry and Nancy
Rosin Collection of
Early Photography
of Japan
Freer|Sackler
Archives

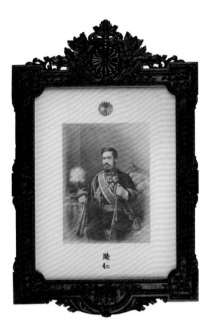

16
Emperor Meiji
Maruki Riyō
(1854–1923), from a
drawing by Eduardo
Chiossone
Japan, 1888
Gelatin silver print
in wood frame,
27.5 × 20.5 cm
Alice Roosevelt
Longworth Collection
Freer|Sackler
Archives

17
Empress Shōken
Photograph taken
by Suzuki Shinichi
(1835–1918) and
printed by Maruki
Riyō (1854–1923)
Japan, 1889
Gelatin silver print
in wood frame,
27.5 × 20.5 cm
Alice Roosevelt
Longworth Collection
Freer|Sackler
Archives

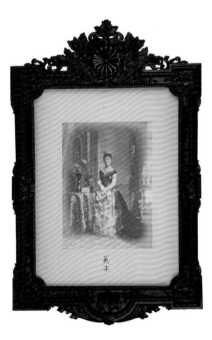

On her journey with the Taft mission, Alice Roosevelt arrived in Seoul in late September 1905. These two portraits were given directly to Alice by the Korean emperor, who saw the United States as the last defender of an independent Korea in the face of increasing Japanese domination. By that time, however, the Americans had already determined Korea's fate in the context of their own Pacific ambitions. Within two months of Alice's visit to Seoul, the Japanese government effectively made Korea a protectorate with no authority to conduct diplomatic activities. The slide toward domination continued until Emperor Gojong was deposed and Korea was formally annexed into the Japanese Empire in 1910.

The portraits given to Alice thus were the imperial Korean government's last attempt to project an image of legitimacy to the American president. Gojong, who was fond of having his picture taken, often sat for foreign photographers. But a recently discovered, signed and dated print from this particular session reveals that the portraits were taken around 1905 by **Kim Kyu-jin** (1868–1933)—establishing them as the first imperial portraits taken by a Korean photographer. Colors were added to the photographs, an unusual element for Korean portrait photography.

18
Portrait of Emperor Gojong
Kim Kyu-jin
(1868–1933)
Korea, ca. 1905
Hand-tinted gelatin silver print, 27 × 21 cm
Alice Roosevelt Longworth Collection
Freer|Sackler Archives

19
Crown Prince Sunjong
Kim Kyu-jin
(1868–1933)
Korea, 1905
Hand-tinted gelatin silver print, 27 × 21 cm
Alice Roosevelt Longworth Collection
Freer|Sackler Archives

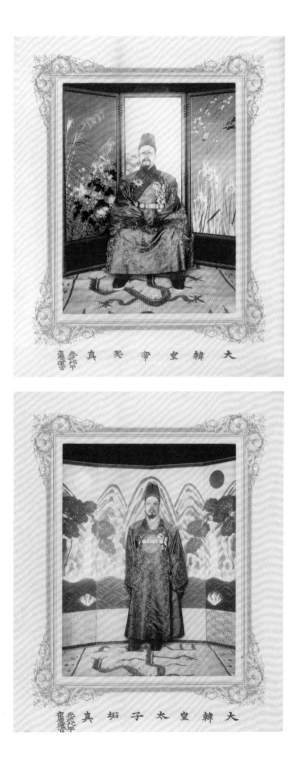

大韓皇帝䚷真
癸卯年
薈雲

大韓皇太子坥真
癸卯年
在灣

The empress dowager Cixi (1835–1908) also saw photography as a tool for projecting her authority to Western viewers. **Xunling** (circa 1880–1943), a minor court official who had learned the photographic process in Tokyo and Paris, was tasked with assisting the empress in crafting her own image. Their collaboration resulted in images that reveal the tensions and connections among traditional styles of Chinese court portraiture and the new technology of the day (figs. 20–22).

While historically viewed as simply the narcissistic diversion of a corrupt ruler, recent scholarship suggests a more purposeful objective within Cixi's photos: using elements of Buddhist iconography and classical Chinese theater to convey specific significance to an educated Chinese elite. The photo in which she gazes into a mirror while placing a flower in her hair (fig. 24) may reference an important scene in the Ming dynasty play *The Peony Pavilion*, which would have been familiar to most members of the Chinese court. In another series of images, Cixi took on the role of Avalokitesvara, the Buddhist bodhisattva of compassion, while standing before a painted backdrop representing Guanyin's Purple Bamboo Grove (fig. 23). Her attendants adopted the guises of the bodhisattva's attendants. Cixi's portrayal of herself as a divinity fell within the tradition of imperial portraits and in fact was an act of reverential devotion.

20
The empress dowager Cixi, portrait presented to Alice Roosevelt
Xunling
(ca. 1880–1943)
China, 1903–5
Gelatin silver print,
23 × 17 cm
Alice Roosevelt Longworth Collection
Freer|Sackler Archives

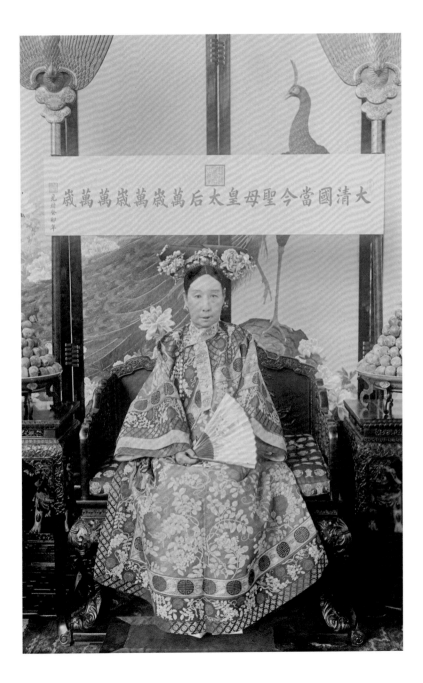

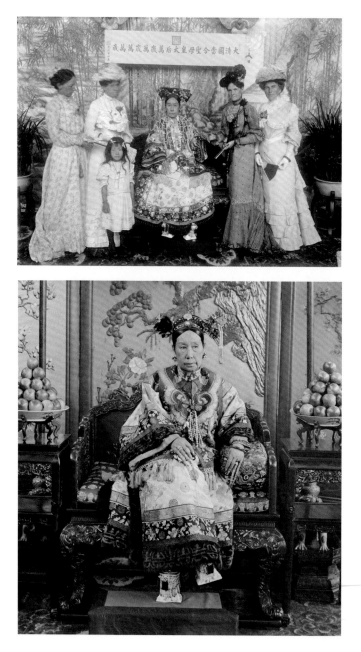

21
*The empress dowager
Cixi with foreign
envoys' wives in
Leshoutang, Summer
Palace*
Xunling
(ca. 1880–1943)
China, Beijing,
1903–4
Glass plate negative,
24.1 × 17.8 cm
Freer|Sackler
Archives

22
*The empress
dowager Cixi*
Xunling
(ca. 1880–1943)
China, 1903–5
Glass plate negative,
24.1 × 17.8 cm
Freer|Sackler
Archives

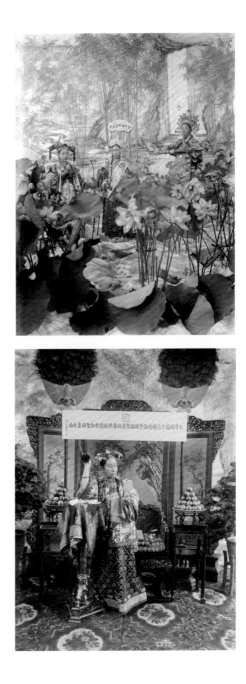

23
*The empress dowager
Cixi in the guise of
Avalokitesvara*
Xunling
(ca. 1880–1943)
China, 1903
Glass plate negative,
24.1 × 17.8 cm
Freer|Sackler
Archives

24
*The empress
dowager Cixi*
Xunling
(ca. 1880–1943)
China, 1903–5
Glass plate negative,
24.1 × 17.8 cm
Freer|Sackler
Archives

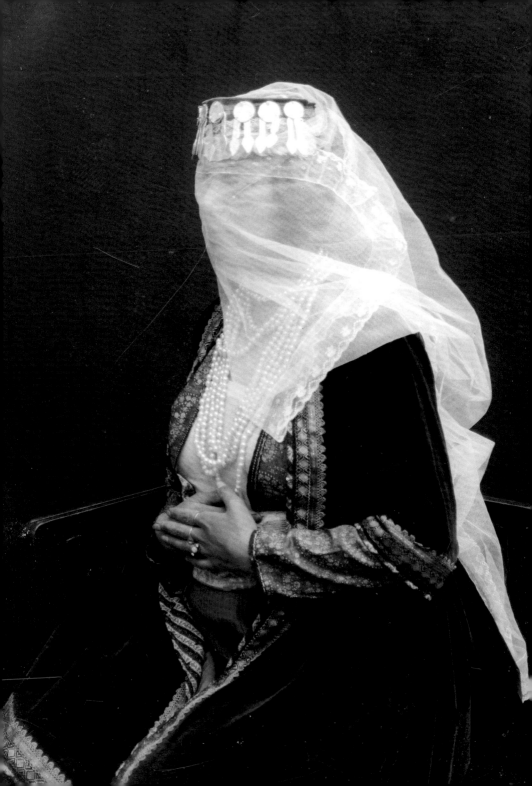

During the late nineteenth century, **Antoin Sevruguin** (died 1933) owned one of the most successful commercial studios in Iran. Born in Tehran and trained in Tbilisi and Moscow, Sevruguin established a studio first in Tabriz in the early 1870s and then in Tehran later in the decade. He was perhaps the most prolific and accomplished photographer of the capital city. His studio was a destination for locals and foreign visitors, some of whom memorialized their travels with elaborate studio portraits (figs. 25, 27, 28). Trained as a painter, he often manipulated his negatives to enhance their dramatic effect.

Sevruguin's commercial success owed not only to his technical and artistic skills but also to aristocratic patronage. Nasir al-Din Shah (reigned 1848–96; figs. 26, 29, 30) was an amateur photographer, and he recognized that photography was a powerful symbol of his modernization of Iran. Sevruguin was one of several photographers active in the court, but his long association with the shah gave him unprecedented access. In one image, Nasir is seen at a distance inside a palace, surrounded by courtiers (fig. 29). Sevruguin obliquely inserted himself (and his camera) into the composition via the mirror's reflection in the background. The shah's own enthusiasm for photography suggests that he would not have objected to Sevruguin's presence in the image; he may have even suggested it.

In addition to taking official portraits of the shah, Sevruguin captured more informal moments, such as the scene in which a Western barber seems to be dyeing the shah's mustache (fig. 30). Recording such an event likely was meant to confirm the power of the shah, showing that he could engage even a Westerner to perform such tasks.

25
Veiled Woman
Antoin Sevruguin
(d. 1933)
Iran, early 20th century
Glass plate negative, 11.8 × 8.8 cm
Myron Bement Smith Papers, Freer|Sackler Archives

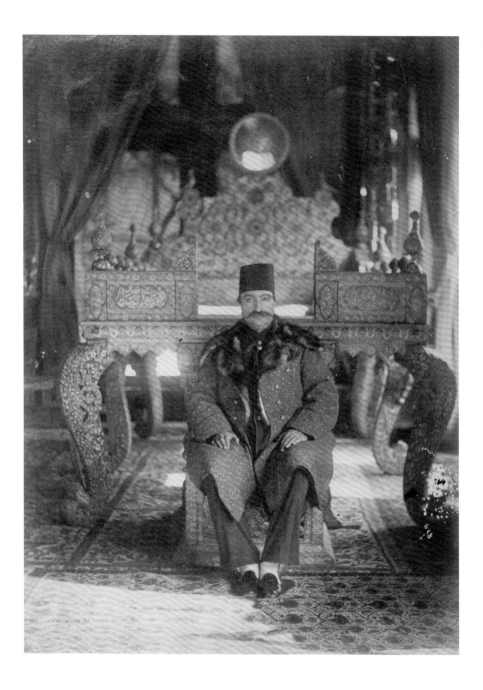

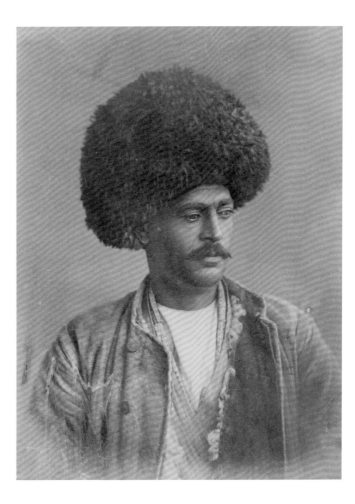

26
*Nasir al-Din Shah
sitting before the
Peacock Throne, in
the Gulistan Palace,
Tehran*
Antoin Sevruguin
(d. 1933)
Iran, late 19th century
Albumen print,
15.5 × 20.7 cm
Jay Bisno Collection
of Sevruguin
Photographs
Freer|Sackler
Archives

27
*Persian Turkman
wearing elaborate
headdress*
Antoin Sevruguin (d.
1933)
Iran, ca. 1880
Albumen print,
16 × 21.3 cm
Stephen Arpee
Album, Freer|Sackler
Archives

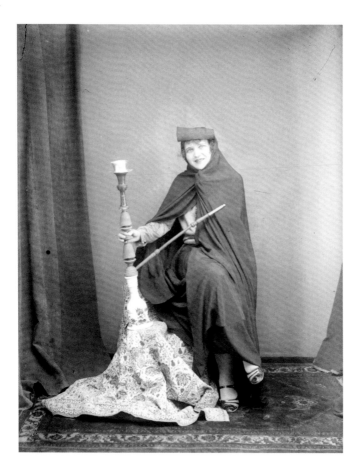

28
*Western Woman in
Studio Posed with
Chador and Hookah*
Antoin Sevruguin
(d. 1933)
Iran, early 20th
century
Glass plate negative,
12.7 × 17.7 cm
Myron Bement
Smith Collection,
Freer|Sackler
Archives

29
*Nasir al-Din Shah
at his desk*
Antoin Sevruguin
(d. 1933)
Iran, ca. 1890
Glass plate negative,
17.7 × 13 cm
Myron Bement Smith
Papers, Freer|Sackler
Archives

30
*Nasir al-Din Shah
being attended to by
a European barber*
Antoin Sevruguin
(d. 1933)
Iran, late 19th century
Glass plate negative,
23.8 × 17.8 cm
Myron Bement Smith
Papers, Freer|Sackler
Archives

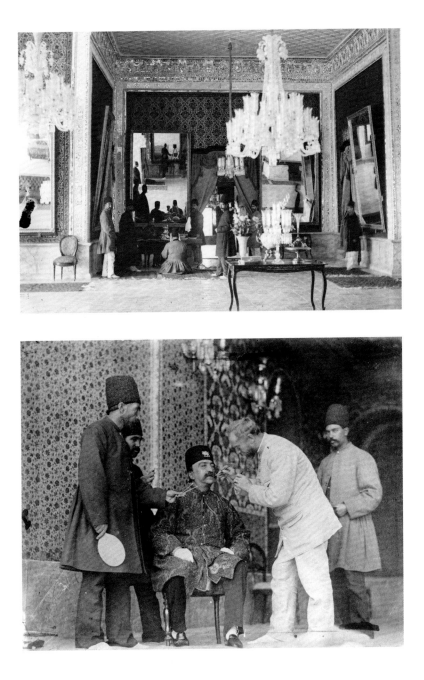

Much like Sevruguin, the late Iranian photographer **Bahman Jalali** (1945–2010) created extensive visual essays documenting Iran's changing landscape and people. However, in his final series, Image of Imagination, Jalali manipulated portraits by Sevruguin and other early Iranian photographers to question the role of images in understanding history. He altered archival photos by superimposing multiple images and pulling them into the present with colors or text, and then reshot the final compositions. The resulting prints evoke photography's malleable role in shaping memory.

By prominently placing archival portraits of women in many of his compositions, Jalali also points to the complicated history of representing women in photography. In one example, a winged woman with a dreamlike gaze and languid pose hovers in front of a row of suited men, while in another image, two enigmatic figures smile beneath the bold color of crushed flowers. Like apparitions emerging from the forgotten corners of the archive, these portraits occupy a liminal space between past and present, reality and imagination.

31
Black and White I
From the series Image of Imagination
Bahman Jalali
(1945–2010)
2000
Gelatin silver print, 25 × 33.6 cm
Purchase—Jahangir and Eleanor Amuzegar Endowment for Contemporary Iranian Art
Arthur M. Sackler Gallery, S2013.8

32
Flowers
From the series Image of Imagination
Bahman Jalali
(1945–2010)
2004
Chromogenic print, 42 × 42 cm
Purchase—Jahangir and Eleanor Amuzegar Endowment for Contemporary Iranian Art
Arthur M. Sackler Gallery, S2013.9

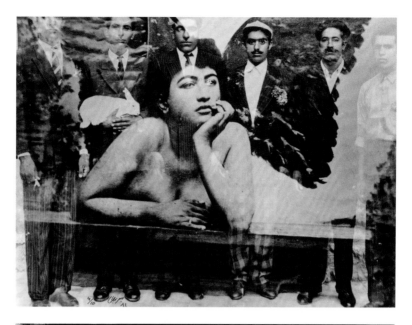

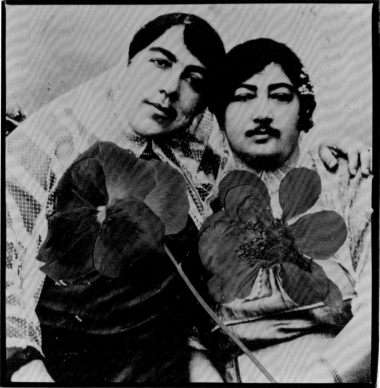

Studying abroad during the 1970s and unable to return home to Iran, **Malekeh Nayiny** (born 1955) turned to old family photographs to travel through time and reestablish a link to her past. In three works from the series Updating a Family Album, Nayiny scanned and digitally manipulated portraits originally taken in the popular nineteenth-century style of the carte de visite (visiting card). Seated at tables and staring solemnly into the camera, her grandfather and uncles (figs. 33–35) are surrounded by whimsical patterns, vivid colors, and curious props. A parrot, objects on draped tables, and elaborate backdrops are reminiscent of visual elements found in traditional Iranian painted portraits to indicate the subject's social rank and sophistication.

These carefully arranged scenes, with hints of sepia and stylized borders, resemble European-inspired photographic portraits. Nayiny's addition of the collage of patterns and a portrait of Imam Ali (the cousin and son-in-law of the Prophet Muhammad; fig. 33) recast her subjects in a new historical context. The vibrant hues and patterns also accentuate the images' artificiality, emphasizing that the photographic portrait is open to continuous reinterpretation.

33
Untitled (Grandfather)
From the series
Updating a Family
Album
Malekeh Nayiny
(b. 1955, Iran)
1997
Color photograph
made from altered
digital image,
42 × 29.6 cm
Purchase—
Arthur M. Sackler
Gallery, S2000.122

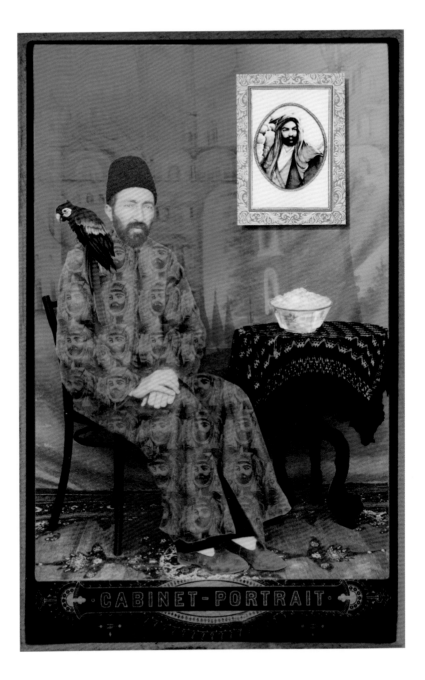

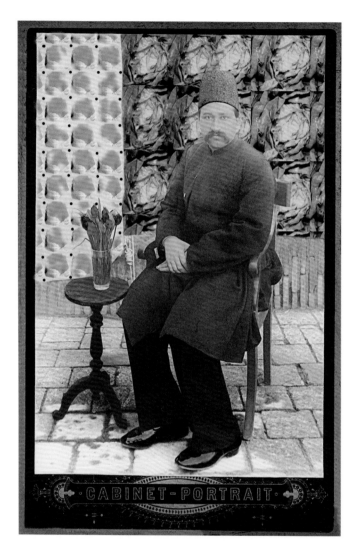

CABINET-PORTRAIT

34
Untitled (Uncle)
From the series
Updating a Family
Album
Malekeh Nayiny
(b. 1955, Iran)
1997
Color photograph
made from altered
digital image,
42 × 29.6 cm
Purchase—
Arthur M. Sackler
Gallery, S2000.123

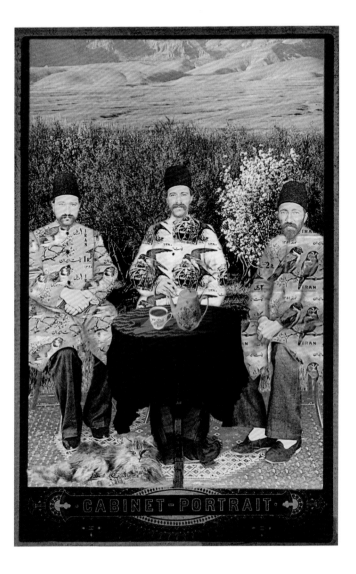

35
*Untitled
(Three Uncles)*
From the series
Updating a Family
Album
Malekeh Nayiny
(b. 1955, Iran)
1998
Color photograph
made from altered
digital image,
42 × 29.6 cm
Purchase—
Arthur M. Sackler
Gallery, S2000.124

Shadafarin Ghadirian (born 1976), a student of Bahman Jalali (see page 38), employs the conventions of early studio portraiture to convey her experience as a young woman living in today's Iran. In seven photographs from her Qajar series, female sitters are dressed in styles typical of the late Qajar period (late nineteenth–early twentieth century). Indoors, they wore headscarves, short skirts, and full pantaloons; outside the home, they donned long veils with face covers. Ghadirian's subjects hold stiff poses and are surrounded by familiar studio-portrait props, including carpets and painted backdrops of stylized plants and flowers, ornate columns, and plush drapes.

Isolated in this suffocating environment, each sitter poses with an object that subverts the sense of timelessness and exoticism associated with historical portraits of the "Oriental" woman. One haunting photograph portrays a fully veiled figure holding a potted plant, a lonely symbol of hope and renewal (fig. 36); in another, the subject turns away from the viewer to stare at her blurred reflection in a mirror (fig. 37). Ghadirian also references notions of freedom in these images. Two veiled figures hold a mirror reflecting a bookcase filled with English and Persian volumes (fig. 38), a woman boldly reads a progressive (now banned) newspaper (fig. 39), and two women—one defiantly unveiled—stand with a bicycle, referring to the controversy in Iran over women riding bicycles in public (fig. 40). In the final pair of photographs, a sitter holds a Pepsi can—a symbol of Western culture and its freedoms—then confidently tosses it as if to assert her power to make her own choices (figs. 41, 42).

36
Untitled (woman with potted plant)
From the series Qajar
Shadafarin Ghadirian
(b. 1976, Iran)
1999
Gelatin silver print,
25.2 × 20.1 cm
Purchase—Arthur
M. Sackler Gallery,
S2000.3

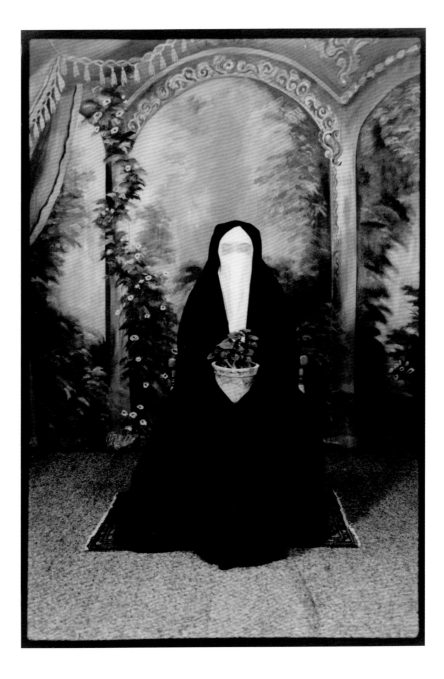

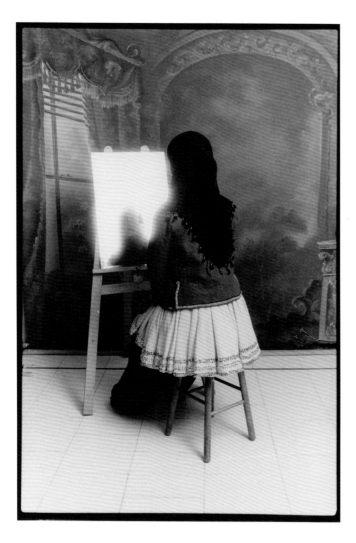

37
Untitled (seated woman in front of mirror)
From the series Qajar
Shadafarin Ghadirian
(b. 1976, Iran)
1999
Gelatin silver print,
25.2 × 20.1 cm
Purchase—Arthur
M. Sackler Gallery,
S2000.4

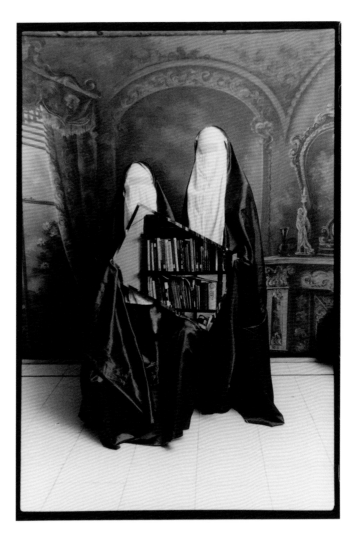

38
Untitled (two veiled women holding mirror)
From the series Qajar
Shadafarin Ghadirian
(b. 1976, Iran)
1999
Gelatin silver print,
25.2 × 20.2 cm
Purchase—Arthur
M. Sackler Gallery,
S2000.5

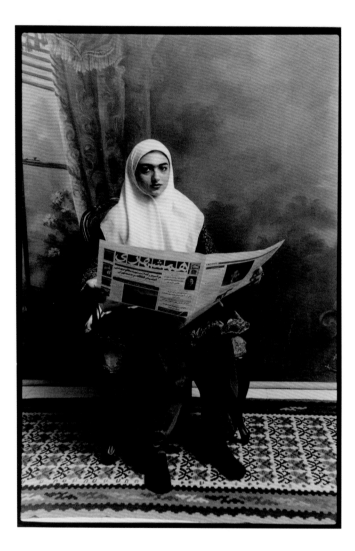

39
Untitled (woman reading newspaper)
From the series Qajar
Shadafarin Ghadirian
(b. 1976, Iran)
1999
Gelatin silver print,
25.2 × 20.2 cm
Purchase—Arthur
M. Sackler Gallery,
S2000.6

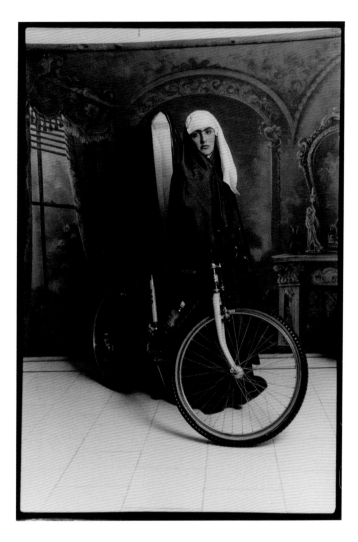

40
*Untitled
(woman with bicycle)*
From the series Qajar
Shadafarin Ghadirian
(b. 1976, Iran)
1999
Gelatin silver print,
25.2 × 20.1 cm
Purchase—Arthur
M. Sackler Gallery,
S2000.2

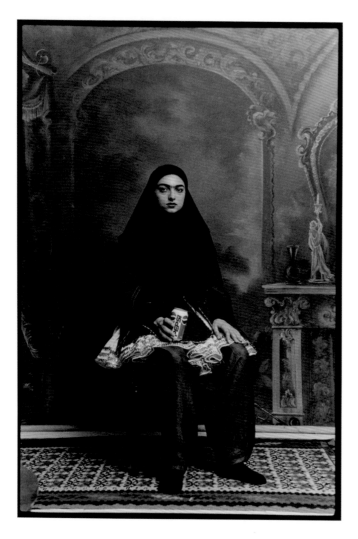

41
Untitled (woman holding Pepsi can)
From the series Qajar
Shadafarin Ghadirian
(b. 1976, Iran)
1999
Gelatin silver print,
25.2 × 20.2 cm
Purchase—Arthur
M. Sackler Gallery,
S2000.7

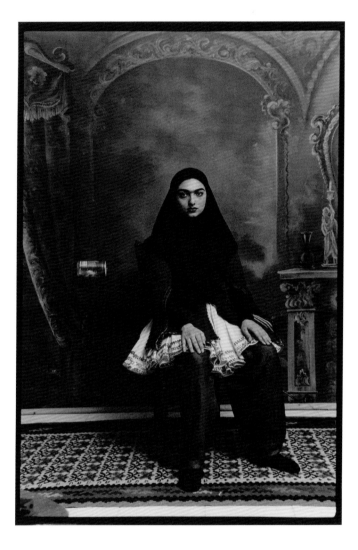

42
*Untitled
(seated woman with
Pepsi can in mid-air)*
From the series Qajar
Shadafarin Ghadirian
(b. 1976, Iran)
1999
Gelatin silver print,
25.2 × 20.2 cm
Purchase—Arthur
M. Sackler Gallery,
S2000.8

Drawing on her Iraqi-Irish background and using her family—and herself—as subjects, **Jananne Al-Ani** (born 1966) adds a personal dimension to her exploration of shifting identities. She arranged her mother, three sisters, and herself according to age and in progressive stages of veiling, forming images that reinterpret late nineteenth- and early twentieth-century portraits of the exotic "Oriental" woman. In *Untitled I*, Al-Ani appears second from the right with her face revealed (also pages 6–7). Reversing the order in *Untitled II*, the artist makes only her eyes visible. Moving back and forth across the figures, from a mother to her youngest daughter and between the concealed and the entirely unveiled, these works question photography's capacity to represent its subjects. Supposedly distinct categories—such as East and West or past and present—are complicated further by the denim shorts and other fragments of contemporary clothing that emerge from the shadows. Through scale and composition, Al-Ani subverts earlier Orientalist portraits and their objectification of the female subject.

Originally purchased as color photographs printed with technology available at the time, these large-scale prints were later replaced with fiber-based gelatin silver prints.

43
Untitled I and II
Jananne Al-Ani
(b. 1966, Iraq)
1996
Color photographic
prints from black-and-white internegatives,
132.7 × 185.4 cm
Purchase—Arthur M.
Sackler Gallery,
S1998.112.1–2

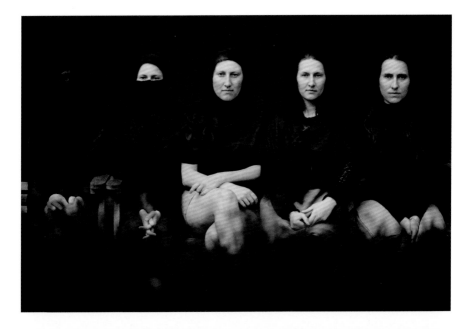

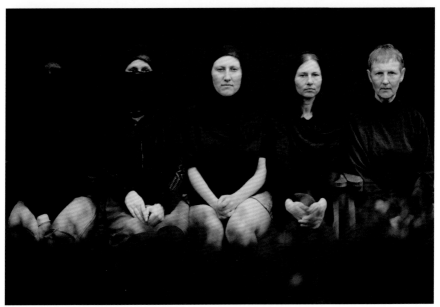

The portrait takes a more introspective turn in the work of **Pamela Singh** (born 1962). A former photojournalist, Singh began to explore the material and interpretive possibilities of photography in the late 1990s. Working with traditionally trained artists in Jaipur, she created a series of hand-tinted photographs using techniques popularized in the late nineteenth century by commercial studios in India.[1] She first enlarged her photographs and then applied color with cotton wool, a brush, or her thumb, employing a tactile process to enhance the meditative mood of her images. In *Self-portrait, 1997 (Swiss Cottage)*, Singh's sleeping figure is gently enveloped by soft, pastel hues and enigmatic shadows. The setting and format of the photograph are not tied to any specific era or culture; her face is only partially visible, and the room is bare, with just a few personal items next to an ordinary bed. Attention is drawn to Singh's use of color and her treatment of the print's surface to heighten the sense of intimacy and dreamlike subject matter. With the delicate application of color, she transforms the photograph into an emotive, rather than descriptive, portrayal.

44
*Self-portrait, 1997
(Swiss Cottage)*
Pamela Singh
(b. 1962, India)
1997
Gelatin silver print,
hand painted with
acrylic and gouache,
67.9 × 101 cm
Purchase—funds
provided by the
Friends of the Freer
and Sackler Galleries
Arthur M. Sackler
Gallery, S2013.5

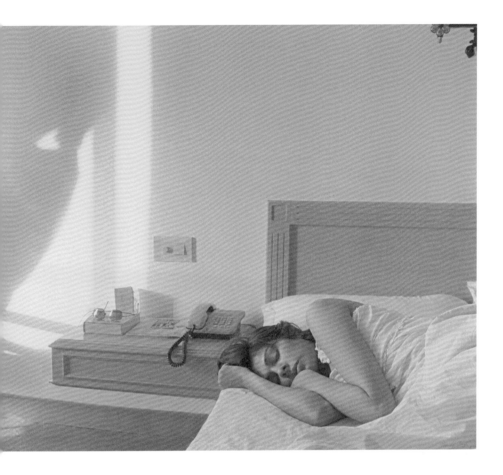

The performative aspect of self-portraiture is the basis for *Yogini* from the series Native Women of South India: Manners and Customs. Collaborating with photojournalist Clare Arni, **Pushpamala N.** (born 1956) recreated more than two hundred photographs of Indian women as they were seen in colonial-period ethnographic albums, as well as in popular imagery from magazines, paintings, film stills, and advertisements. *Yogini* recreates *Yogini with Mynah*, a seventeenth-century Indian painting in which the bejeweled central figure, with her ashen complexion and topknot, likely represents a princess or female ascetic and reinforces the idea of "the divine feminine" in Indian culture.[2] By casting herself as the elegantly adorned yogini gazing gently at a bird against a painted backdrop, Pushpamala N. attempts to embody an enduring representation of the female Indian subject. Yet, subtle details—such as the shadow she casts and the sliver of studio floor visible at the bottom of the photograph—remind the viewer of the constructed nature of both the image and the notion of a feminine ideal.

45
Yogini
From the series
Native Women of
South India: Manners
and Customs
Pushpamala N.
(b. 1956, India), Clare
Arni (b. 1962, United
Kingdom)
2000–2004
Chromogenic print,
55.8 × 43.9 cm
Anonymous gift in
memory of Nasser
Ahari
Arthur M. Sackler
Gallery, S2013.1

45B
Yogini with Mynah
India, Karnataka, Bijapur
ca. 1603–4
Opaque watercolor and
gold on paper
The Trustees of the
Chester Beatty Library,
Dublin In 11a.31

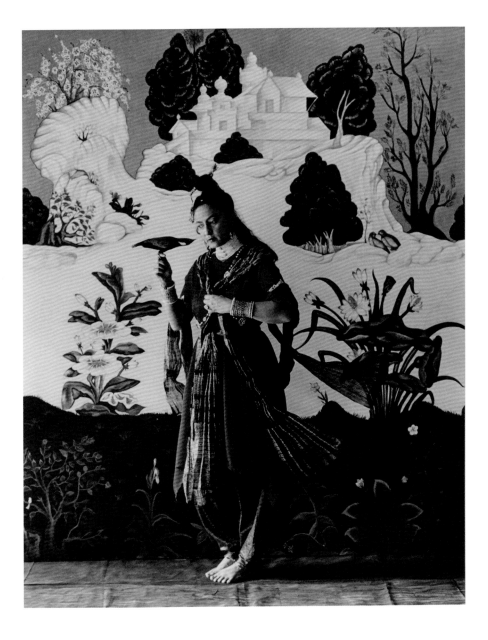

Since the late 1990s, **Gauri Gill** (born 1970) has been photographing marginalized communities in the remote desert region of western Rajasthan, India. In 2003, she was asked to participate in a Balika Mela, a fair that provides girls the opportunity to learn and play in a safe environment. Gill led workshops teaching basic photography and darkroom techniques.

Reminiscent of the traditional itinerant photographer who would travel from village to village with his equipment, Gill also invited the girls to have their portraits taken in a makeshift studio. She gathered backdrops and props from local sources and asked the sitters to choose how and with whom they wanted to be photographed. From the nearly seventy portraits, she chose three to be printed at close to life-size. With a direct gaze and slightly clenched hands, *Kanta* conveys a sense of determination and cautious self-awareness. *Raami*, kneeling with a camera on her knee and one arm draped casually over a table (fig. 3; page 11), and *Revanti*, with her whimsical gesture, suggest the last fleeting days of girlhood. The spare use of props, plain backdrops, and natural desert light emphasize Gill's subjects, while the large scale of the black-and-white prints asserts an iconic, self-empowered status.

A key figure in Gill's work in Rajasthan is Izmat, a single mother she has known for nearly two decades. Gill repeatedly photographed Izmat, whom the artist has described as a "strong woman of tremendous character despite having lived a very difficult life," and her two daughters, Jannat (1984–2007) and Hurra. In a portrait from the series Notes from the Desert (1999–present) (fig. 48). Izmat's face emerges from the dark foliage of a tree set against the blinding light of the desert sky. Barely perceptible in the stark landscape and shot from below, she challenges the viewer's gaze.

Gill frequently revisits her vast archive of negatives and composes different series around a central theme. In 2009, she gathered under the title Jannat forty-four photographs and eight facsimiles of letters that she and Izmat had exchanged (fig. 49). This group of prints, one for each week of the year, is a poignant memorial to Izmat's daughter who died at twenty-three. A portrayal of Jannat unfolds through glimpses of the joy, pain, and tenderness of everyday life.

46
facing page
Kanta
From the
series Balika Mela
Gauri Gill
(b. 1970, India)
2003–10
Inkjet print,
160 × 106.7 cm
Purchase—
Friends of the Freer
and Sackler Galleries
Arthur M. Sackler
Gallery, S2013.6

47
page 60
Revanti
From the series Balika Mela
Gauri Gill
(b. 1970, India)
2003
Inkjet print,
159.4 × 106.4 cm
Purchase—
Friends of the Freer
and Sackler Galleries
Arthur M. Sackler
Gallery, S2014.14

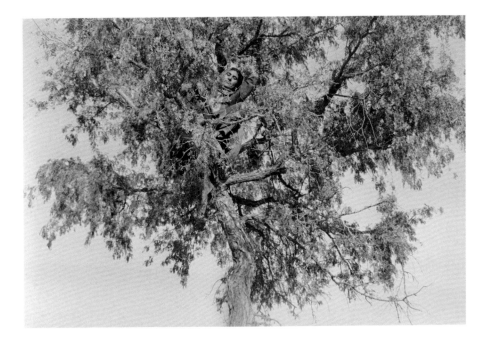

48
Izmat
From the series Notes
from the Desert
Gauri Gill
(b. 1970, India)
1999–2010
Gelatin silver print,
61 × 76.2 cm
Purchase—
Friends of the Freer
and Sackler Galleries
Arthur M. Sackler
Gallery, S2014.16

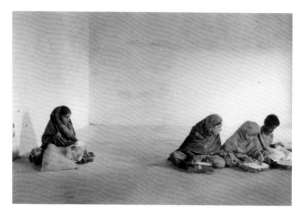
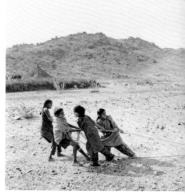
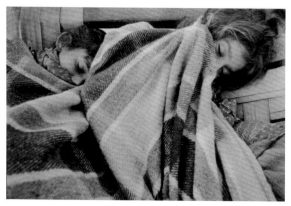
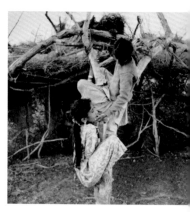
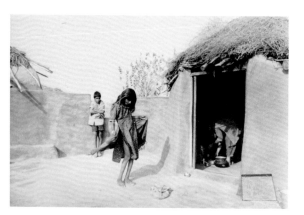
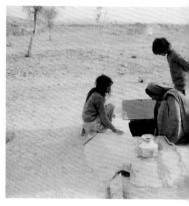

> Read For Enjoyment
>
> Good Habits
>
> Every night my prayers i say.
> And got my dinner every day
> And every day that i've been good
> i got an orange after food.
>
> the child that is not clean and neat
> with lots of toys and things to eat
> he is naughty child, i'm sure.
> Or else his habits are poor

49
Selections from
Jannat (1984–2007)
Gauri Gill
(b. 1970, India)
1999–2007
Gelatin silver and
inkjet prints, 11.5 ×
17.2 cm (each image),
15.2 × 16 cm (letter)
Purchase—
Friends of the Freer
and Sackler Galleries
Arthur M. Sackler
Gallery, S2014.15.1–52

In sharp contrast to Gauri Gill's approach, **Suh Do-Ho** (born 1962) layers and repeats images to depersonalize his portraits. For *High school Uni-face (Boy)* and *High school Uni-face (Girl)*, he reproduced photographs from his own high-school yearbook (figs. 51, 52). Layered on top of each other with blurred features and set against a stark white background, hundreds of faces are merged into two larger-than-life figures that simultaneously confront and elude the viewer.

From a distance, the faces in *Who Am We?* appear to dissolve into a uniform pattern of neutral tones. Up close, the viewer discovers thousands of individual faces staring back, each one revealing subtle differences in hair, facial features, and expressions. Through scale, pattern, and color, Suh immerses the viewer in the tension between individual identity and the overwhelming anonymity of the larger social community.

50
Who Am We?
Suh Do-Ho (b. 1962,
Republic of Korea)
2000
Four-color offset
prints on coated
paper, 61 × 91.4 cm
Purchase—funds
provided by the
Friends of the Freer
and Sackler Galleries
Arthur M.
Sackler Gallery,
S2006.34.3.1–44

51
High school Uni-face (Boy)
Suh Do-Ho (b. 1962, Republic of Korea)
1997
Color photograph made from altered digital image,
175.3 × 127 cm
Purchase—funds provided by the Friends of the Freer and Sackler Galleries
Arthur M. Sackler Gallery, S2006.34.1

52
High school Uni-face (Girl)
Suh Do-Ho (b. 1962, Republic of Korea)
1997
Color photograph made from altered digital image, 175.3 × 127 cm
Purchase—funds provided by the Friends of the Freer and Sackler Galleries
Arthur M. Sackler Gallery, S2006.34.2

The sense of anonymity and unease that pervades contemporary society lies at the core of **Mitra Tabrizian's** (born 1958) carefully staged images. In her Border series, Tabrizian focused on Iranians in London and the migrant's sense of alienation and loss—and the hopeless fantasy to return home. In *A Long Wait*, a woman sits in a sparsely furnished room, soft light illuminating her face. Next to a closed door, a suitcase seems heavy with the weight of memories; it is both a symbol of her desire to go home and an obstacle to her exit. Her expressionless gaze, framed within the haunting setting, poignantly evokes the exile's persistent state of waiting and the impossibility of return.

The introduction of a second figure in *Deadly Affair* amplifies the solitude of Arash, a former high-ranking soldier in Iran who now works as a mechanic outside London. In spite of the sense of vigilance and order set in his facial features, Arash, in his blue smock, stares distractedly into the far distance. In the background, a young man stands helplessly next to a shattered car window. The lack of interaction between the two figures leaves Arash suspended in time and place, with only a cat for a companion. He exists elsewhere, far from a life disrupted by displacement and a broken family.

53
A Long Wait
From the series
Border
Mitra Tabrizian
(b. 1958, Iran)
2005–6
Chromogenic print,
125.4 × 154.9 cm
Purchase—
Jahangir and
Eleanor Amuzegar
Endowment for
Contemporary
Iranian Art
Arthur M. Sackler
Gallery, S2014.3

54
Deadly Affair
From the series
Border
Mitra Tabrizian
(b. 1958, Iran)
2005–6
Chromogenic print,
124.5 × 156.2 cm
Purchase—
Jahangir and
Eleanor Amuzegar
Endowment for
Contemporary
Iranian Art
Arthur M. Sackler
Gallery, S2014.4

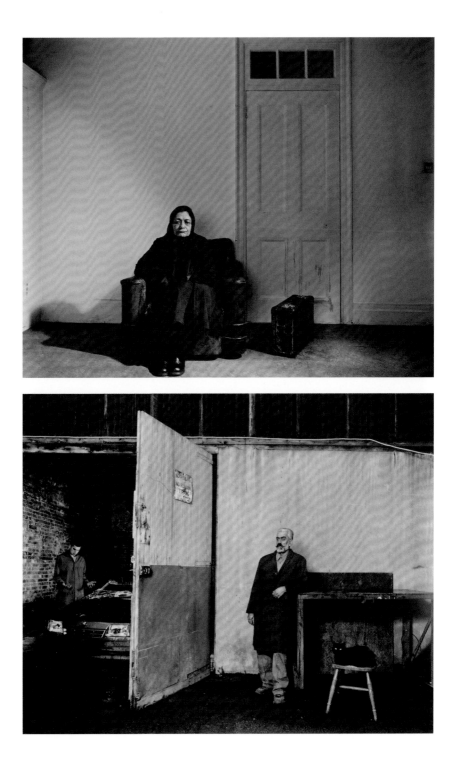

Empty landscapes become stages for the self-portraits of
Tarek Al-Ghoussein (born 1962). The son of exiled Palestinians,
Al-Ghoussein is a Kuwaiti national prohibited from visiting
Palestine. Much of his work centers on the social and psychological
impacts of displacement. In the series K Files, he focuses on sites
that were central to Kuwait's modernization and national identity.
Qasr al-Salam, the setting for *K Files 117*, was an opulent guesthouse
that the Kuwaiti government used for hosting foreign dignitaries.
Bombed and looted by the Iraqi army in 1990, the building was
never restored.

K Files 403 (fig. 56) was shot in the courtyard of a school
named after Abdullah Al-Salim, the first emir of Kuwait
(reigned 1950–65), which also fell into disuse after the 1990
invasion. The faded grandeur of these "national works" calls
attention to this major event in modern Kuwaiti history, which
left thousands of Palestinians in a state of double exile from
both homeland and adopted country.

Al-Ghoussein's solitary figure, at a small scale and partially
obscured in the dusty shadows of the two abandoned sites,
embodies a profound sense of loneliness. In *K Files 503* (fig. 57),
he stands in the waters of the Kuwait Bay, facing a vast horizon, the
National Assembly building and Umm Al-Gaz Island just outside the
frame. These three views are anchored by elements found at the
margins—a broken chandelier, overgrown tree, or the photographer
himself—and convey both a sense of place and an aura of loss
and detachment.

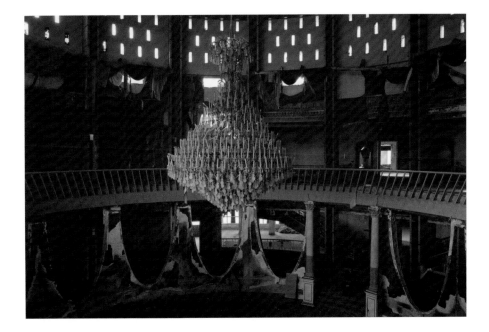

55
K Files 117
Tarek Al-Ghoussein
(b. 1962, Kuwait)
2013
Archival inkjet print,
90 × 135 cm
Purchase—Friends of
the Freer and Sackler
Galleries
Arthur M. Sackler
Gallery, S2015.4

56
K Files 403
Tarek Al-Ghoussein
(b. 1962, Kuwait)
2013
Archival inkjet print,
90 × 135 cm
Purchase—Friends of
the Freer and Sackler
Galleries
Arthur M. Sackler
Gallery, S2015.5

57
K Files 503
Tarek Al-Ghoussein
(b. 1962, Kuwait)
2013
Archival inkjet print,
90 × 135 cm
Purchase—Friends of
the Freer and Sackler
Galleries
Arthur M. Sackler
Gallery, S2015.6

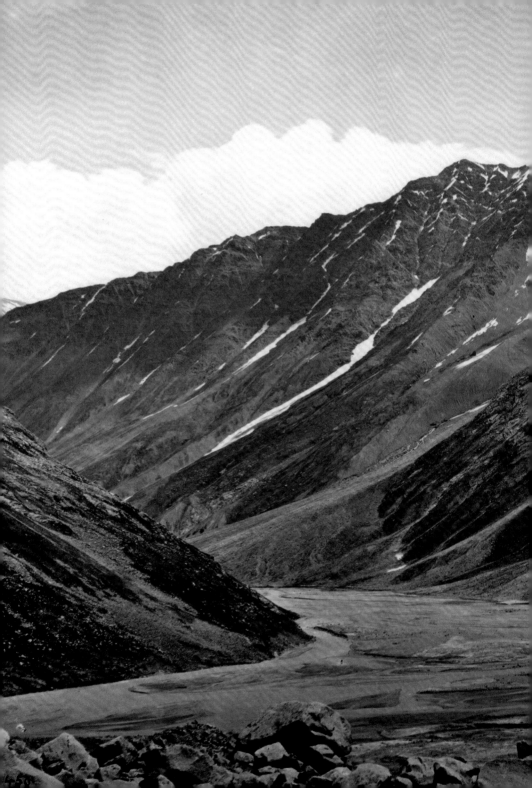

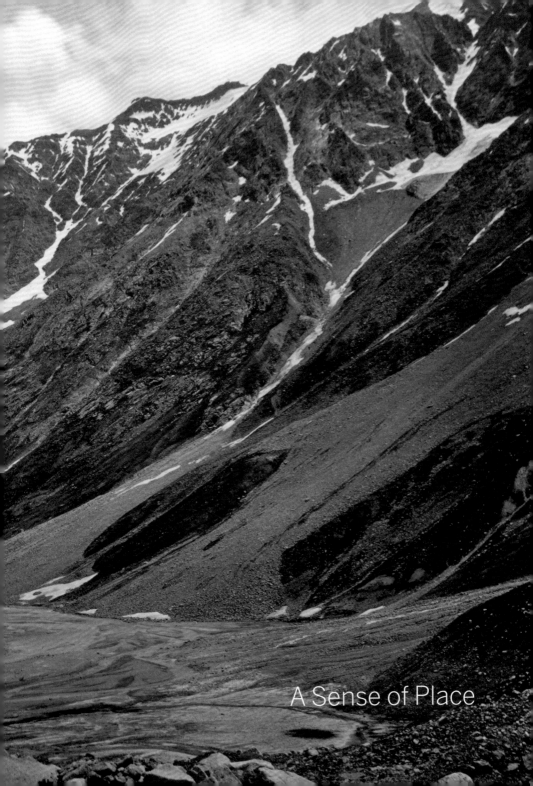

A Sense of Place

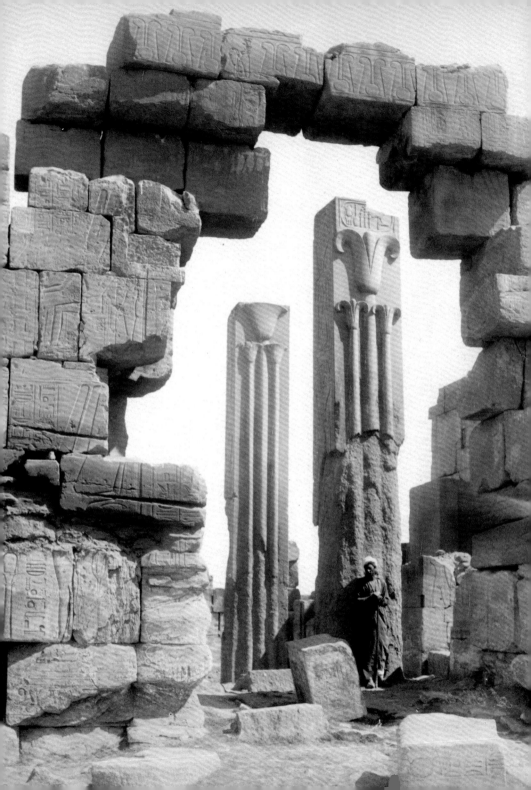

As global commercial travel networks expanded in the nineteenth and early twentieth centuries, photography emerged as the most pervasive technology for visualizing Asia. During his travels through Asia from 1895 to 1911, Charles Lang Freer, the future founder of the Freer Gallery of Art, relied on this new medium to recollect his surroundings. His images became part of the Charles Lang Freer Papers, which in turn became the foundation of the Freer|Sackler Archives. The Freer|Sackler also holds numerous images that illustrate not only the technological advances in photography since its invention, but also how different historical circumstances frame views of a particular place.

Beginning in the 1850s, amateur and professional photographers gathered representative images of faraway places to sell to popular audiences or to use for scholarly research. This early photography was limited by long exposure times and poor tonal range. Photographers not only had to transport bulky equipment and volatile chemicals to remote, inhospitable sites, but the materials were prohibitively expensive and prone to damage and decay. Many of the large-format prints that make up the museum's collections of early photography signify an extraordinarily risky investment.

Photographic societies formed that allowed photographers to exchange information, stay informed of technical innovations, and participate in publications and exhibitions. In South Asia, the established presence of British administrative, military, and trade networks further ensured a steady supply of images. Professional photographer Samuel Bourne (1834–1912) spent seven years (1863–70) traveling throughout the region, even venturing deep into the Himalayas to capture previously unrecorded valleys and glaciers. Bourne created stunning images that were widely distributed in albums and publications, making them among the most commercially successful nineteenth-century photographs of India.

The camera was a rapidly growing presence in Japan as well soon after it first appeared. Commercial studios were especially active at popular tourist stops such as Yokohama during the 1860s. At

58
previous spread
Chandra Valley
Samuel Bourne
(1834–1912)
India, ca. 1860s
Albumen print,
23 × 29 cm
Freer|Sackler
Archives

59
facing page
Pylon of Thutmose II
Antonio Beato
(after 1832–1906)
Karnak, Egypt, late
19th–early 20th
century
Albumen print,
28 × 21.2 cm
Charles Lang Freer
Papers
Freer|Sackler
Archives

the same time, glass plate negatives and albumen printing techniques arrived, facilitating both higher quality prints and mass production.

Prints by Francis Frith, an amateur photographer who traveled to Egypt and Palestine between 1856 and 1860, and images taken by later archaeologists such as Ernst Herzfeld demonstrate an emphasis in these early days on visually documenting the Middle East. The camera's ability to provide seemingly accurate reproductions of reality spurred photographers to organize expeditions to the region's ancient sites. The finely rendered illustrations from Napoleon's 1798 surveys of Egypt had whetted the public imagination and generated tremendous interest among scholars. Photography now promised even more precise records of the monuments and landscapes of the distant past.

While early photographers in Asia valued the medium's ability to capture the physical reality of places (albeit in views shaped by Western conventions and desires), photographers from the later twentieth century to the present have expanded the ways in which landscape views are imbued with meaning. Lois Conner and Hai Bo take highly subjective approaches to capturing the extraordinary scale of China's changing natural and built environment. An-My Lê uses the camera to observe the country-side of Vietnam and understand her own experience of the war. Seifollah Samadian examines the impact of environmental degradation and war on life in Iran.

Where these examples focus on specific places, another selection of works exploits photography's inherent characteristics to address broader concepts. Abbas Kiarostami employs contrast and color to express the universal qualities of the landscape. Lynn Davis and Georg Gerster compose images of archaeological sites that place topographical details second to considerations of perspective, light, and form. Sugimoto Hiroshi's long-exposure views of seascapes around the world become visual meditations on time. Through experimentation, composition, and subject matter, contemporary photographers continue to expand the symbolic and expressive potential of landscape views.

60
Excavation of Persepolis: Gate of All Lands
Ernst Herzfeld
(1879–1948)
Iran, 1923–28
Glass plate negative, 13 × 18 cm
Freer|Sackler Archives

61
A young boy helping his father in their local pottery factory
Seifollah Samadian
(b. 1954, Iran)
1989
Inkjet print, 50 × 75 cm
Purchase—Jahangir and Eleanor Amuzegar Endowment for Contemporary Iranian Art
Arthur M. Sackler Gallery
S2011.15

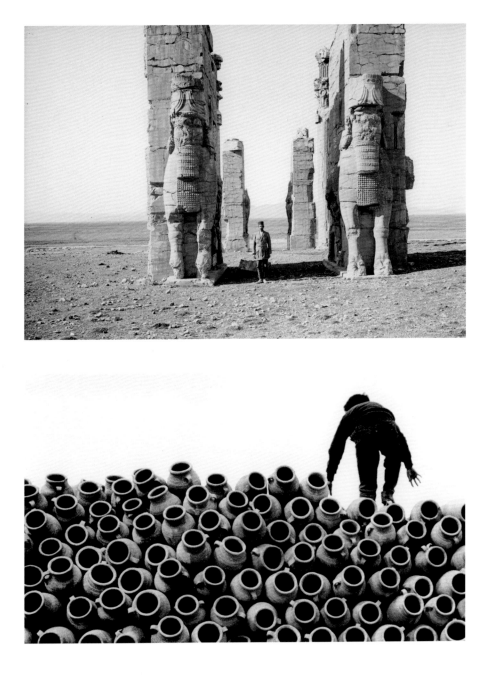

Starting in 1840, British Army captain **Linnaeus Tripe** (1822–1902) was stationed in India, where he also worked as a military surveyor. In 1855, he was commissioned by the British East India Company to photograph archaeological monuments and artifacts, temples, mosques, and government buildings. Tripe's technical and artistic skills are remarkable, particularly since he worked with new photographic equipment and salt-printing chemicals in the challenging climate of South Asia. His images were published extensively in Britain, giving audiences some of their first photographic views of their South Asian colonial holdings.

Like Tripe, **Dr. John Murray** (1809–1898) was hired by the British East India Company to conduct surveys of architecture and military sites while he was living in Agra. A Scottish medical teacher and school administrator, he experimented with the medium and was active in the Photographic Society of Bengal in 1856. Murray's photographs are notable for their large formats and effective use of waxed paper negatives (which he continued to employ well after glass plates had been introduced) to record fine details of Mughal architecture in the Agra region.

62
*Idgah and tomb
at Ryakotta*
Linnaeus Tripe
(1822–1902)
Tamil Nadu, India,
ca. 1856
Albumenized salt
print from waxed
paper negative,
24.1 × 36.8 cm
Freer|Sackler
Archives

63
*Entrance gate to
the Taj Mahal*
John Murray
(1809–1898)
Agra, India,
ca. 1858–62
Albumen print from
waxed paper negative,
36 × 45 cm
Freer|Sackler
Archives

Felice Beato's groundbreaking work across Asia is recognized as pivotal to the advent of photography. As a former soldier, Beato (1832–1909) was able to accompany British armies to conflict areas; he and his business partner James Robertson (1813–1888) were among the earliest photographic war correspondents. In 1858, following the Indian Rebellion (also known as the Sepoy Mutiny), Beato traveled to Delhi and Lucknow, carefully recording the battle sites. His images were published in two albums, which are considered the first photographic narratives of war. In his most famous work from this series, a battle-scarred courtyard is littered with the corpses of mutineers. By some accounts, Beato had the bodies disinterred to make his composition more dramatic.

64
Inside the Secunderabagh [Sikandar Bagh]
Felice Beato (1832–1909)
Lucknow, India, ca. 1858
Albumen print, 26 × 30 cm
Freer|Sackler Archives

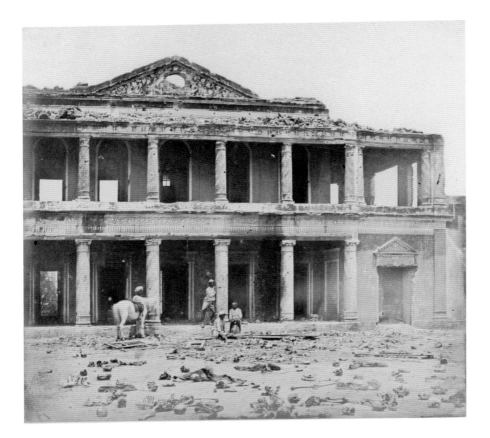

Captain **Eugene Clutterbuck Impey** (1830–1904) was a British
military administrator based mostly in Northern India from 1851.
Sometime during that decade, Impey took up photography as a
hobby. By the 1860s, he was participating frequently in the
exhibitions and publications of the Photographic Society of Bengal.
Impey proved to be a skilled and sensitive photographer, and
he made numerous studies of the Indian landscape and people.
He also happened to be related to Julia Margaret Cameron
(1815–1879), a photographer whose portraits are recognized
for their pioneering use of artistic effects.

65
Palace and Tank
Eugene Clutterbuck
Impey (1830–1904)
Ulwar, India, ca. 1860
Albumen print,
24 × 28.5 cm
Impey Family
Photograph Albums
Freer|Sackler
Archives

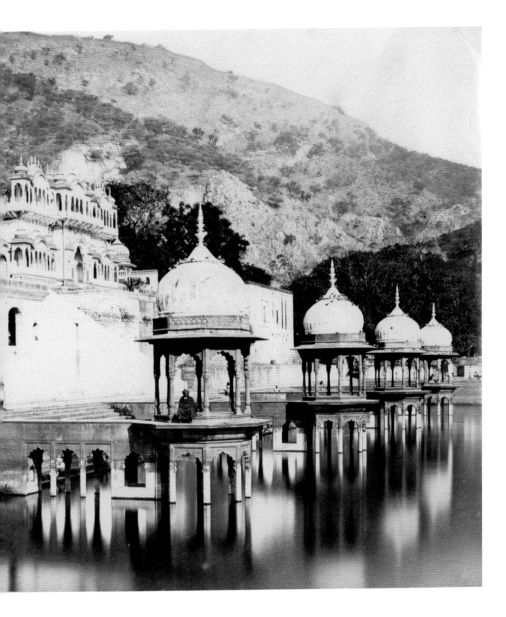

In a letter dated February 18, 1895, Charles Lang Freer wrote: "Oodeypore [Udaipur] gave me supreme pleasure. It's the most beautiful place I have ever seen and nothing could have been more courteous and pleasing than the hospitality of the Maharja [Maharana] and [Prince] Fateh Lal Mehta. . . . I can scarcely ever hope for impressions of any earthly place more completely to my liking than those I expect always to cherish at Oodeypore."

The earliest surviving photographs in the Freer papers were gifts. Fateh Lal gave Freer a set of nineteen albumen prints by **Mohan Lal** (active second half of the nineteenth century), a court painter to the Maharana who likely also worked as a photographer in Udaipur from the 1870s onward. The images are compelling reminders of the palaces and landscapes in and around the former Mewar capital.

66
*Palace complex
at Udaipur*
Mohan Lal (act. 2nd
half of 19th century)
India, 2nd half of 19th
century
Albumen print,
20.3 × 27.3 cm
Charles Lang Freer
Papers
Freer|Sackler
Archive

67
Lake Pichola, Udaipur
Mohan Lal (act. 2nd
half of 19th century)
India, 2nd half of 19th
century
Albumen print,
19.5 × 25.5 cm
Charles Lang Freer
Papers
Freer|Sackler
Archives

In 1907, Freer spent nearly two months exploring the Buddhist monuments of Sri Lanka and Indonesia. In Sri Lanka, he visited the ancient complexes of Anuradhapura and Polonnaruwa and the capital city of Colombo, where he purchased two splendid albums by **F. Skeen and Co.** and a number of loose prints from **Scowen and Co.** (fig. 69). Both operated by British photographers, these two studios were at the fore in Sri Lanka and remained active into the early twentieth century.

In Indonesia, Freer visited the vast ninth-century stupa complex of Borobudur as well as other Buddhist and Hindu monuments in central Java. While in Java, he purchased an album of collodion prints from the studio of the Armenian photographer **Onnes Kurkdjian** (1851–1903) (fig. 70).

68
Jetavanaramaya
Stupa
F. Skeen and Co.
(act. 1860–1920s)
Anuradhapura, Sri
Lanka, late 19th
century
Albumen print from
a bound two-volume
set of albums,
21 × 27.5 cm
Charles Lang Freer
Papers
Freer|Sackler
Archives

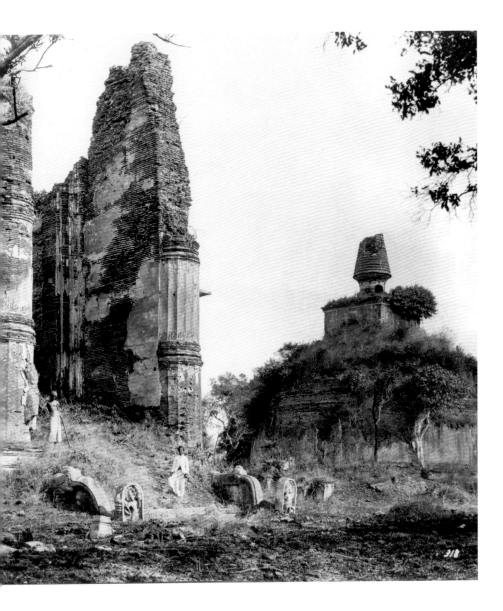

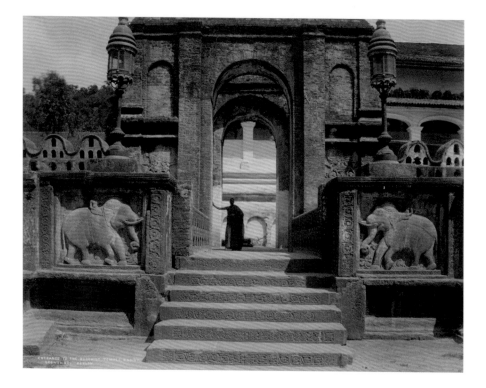

69
Entrance to Buddhist temple
Scowen and Co.
(act. 1870–90)
Kandy, Sri Lanka,
after 1876
Albumen print,
21.5 × 27.7 cm
Charles Lang Freer
Papers
Freer|Sackler
Archives

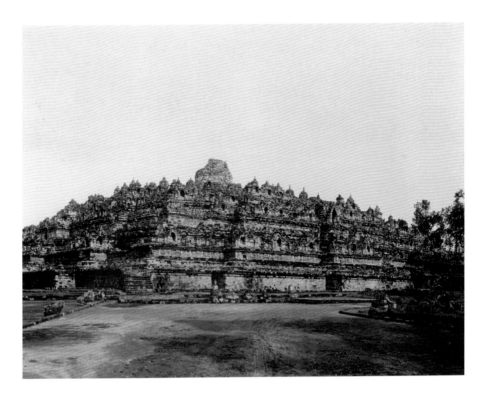

70
Borobudur
Onnes Kurkdjian
(1851–1903)
Indonesia, late 19th
century
Collodion print from
a bound album,
16.7 × 22.5 cm
Charles Lang Freer
Papers
Freer|Sackler
Archives

After his stint in India, **Felice Beato** (1832–1909) arrived in Yokohama in 1863. There, he established one of the first commercial studios that catered to foreign visitors, producing landscapes and portraits recognized for their refinement and grace. Although foreigners in Japan were confined to Yokohama and other enclaves, Beato's military contacts again allowed him to accompany diplomatic delegations to other parts of the country, where he was able to capture subjects previously unavailable to the camera. He also is credited with introducing what would become one of the most notable features of Yokohama commercial photography: hiring Japanese painters to apply watercolors to albumen photographs.

Beato operated his studio in Yokohama until 1877, when he sold his negatives to Baron Raimon von Stillfried, his disciple and competitor. Stillfried continued to market Beato's images into the mid-1880s, well after most Western commercial photographers had given way to Japanese competitors.

71
Ferry at Kanazawa
Felice Beato
(1832–1909)
Japan, 1860s
Hand-tinted albumen
print, 21.4 × 27 cm
Henry and Nancy
Rosin Collection
Freer|Sackler
Archives

72
next spread
*View of Lake Ashi and
Mountains at Hakone*
Felice Beato
(1832–1909)
Japan, 1860s
Albumen print,
21.5 × 28 cm
Freer|Sackler
Archives

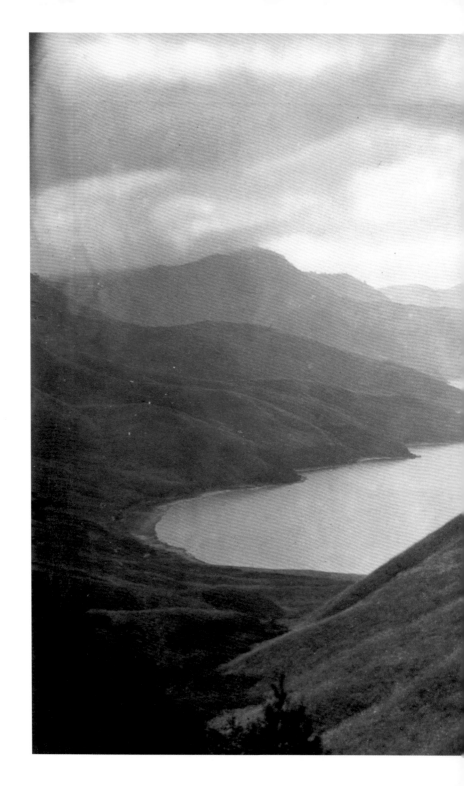

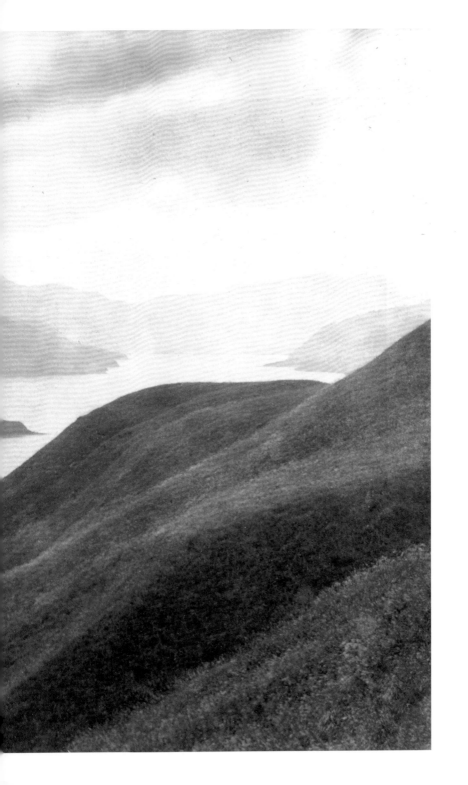

Following his trips to Egypt and Palestine, **Francis Frith** (1822–1898) published large-format prints of Egyptian antiquities and picturesque views in albums that became tremendous commercial successes. One advantage Frith had over photographers who had gone on earlier expeditions to the Middle East was his use of glass plate negatives rather than paper. Glass plates were expensive, heavy, and not suited for rough travel conditions, but they afforded superior tonal range and detail. Frith also added human figures to his compositions of ancient monuments, to provide a sense of scale, some local color, or perhaps a chance for viewers to vicariously experience the pleasure of exploration. It must have been a considerable challenge for Frith to keep his subjects still for the very long exposure times that his photographs required.

In addition to ancient Egyptian monuments, photographers ventured to the Middle East to capture scenes of the Holy Land. Photographers eagerly set out to the eastern Mediterranean to record sights described in the Bible that, for centuries, artists had only visually imagined. The sheer quantity of nineteenth-century photographs of Jerusalem, such as Frith's panorama of the Temple Mount (fig. 75), is extraordinary.

73
*Rock-Tombs and
Beloni's Pyramid*
Francis Frith
(1822–1898)
Giza, Egypt, 1857
Albumen print,
15.6 × 23 cm
Freer|Sackler
Archives

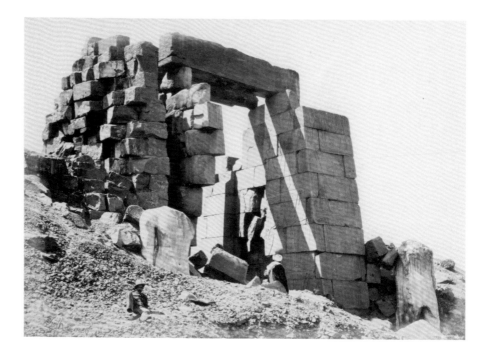

74
Granite Pylon
Francis Frith
(1822–1898)
Karnak, Egypt, 1857
Albumen print,
16 × 22.6 cm
Freer|Sackler
Archives

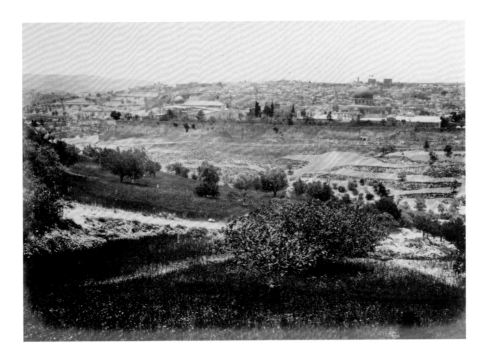

75
*Jerusalem, from the
Mount of Olives*
Francis Frith
(1822–1898)
1857
Albumen print,
16 × 23.2 cm
Freer|Sackler
Archives

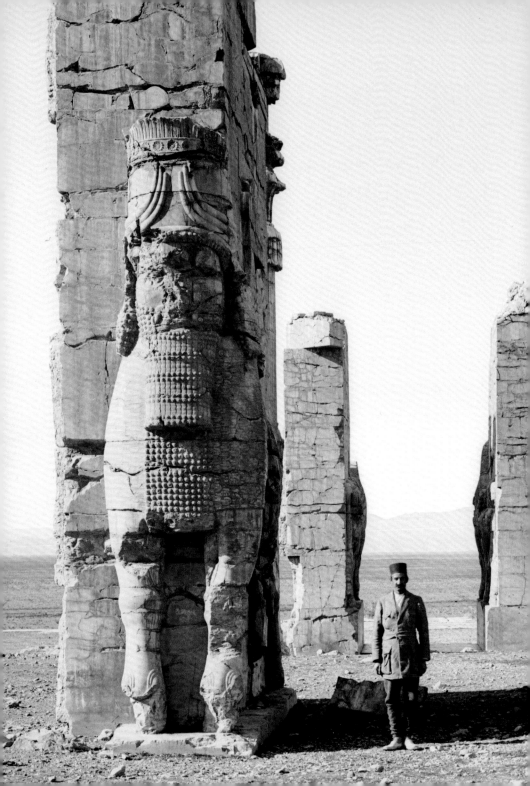

Archaeologists since the mid-nineteenth century have relied on photography as an indispensable tool for documenting excavations. The German archaeologist **Ernst Herzfeld** (1879–1948) took numerous photographs during his pioneering expeditions to Iran and Iraq. Along with geographical and topographical records, he captured sweeping panoramic views that convey the sense of a timeless landscape and the ineffable grandeur of the ancient cities of Persepolis, Samarra, and Ctesiphon.

76
facing page
*Excavation of
Persepolis: Gate
of All Lands*
Ernst Herzfeld
(1879–1948)
Iran, 1923–28
Glass plate negative,
13 × 18 cm
Freer|Sackler
Archives

77
next spread, top
*Ctesiphon:
Taq-i Kisra at Sunrise*
Ernst Herzfeld
(1879–1948)
Iraq, 1907–8
Gelatin silver print
with hand-coloring,
13 × 18 cm
Ernst Herzfeld Papers
Freer|Sackler
Archives

78
next spread, bottom
*Naqsh-i Rustam:
View of the Marv
Dasht Plain*
Ernst Herzfeld
(1879–1948)
Iran, 1923–24
Gelatin silver print,
13 × 18 cm
Ernst Herzfeld Papers
Freer|Sackler
Archives

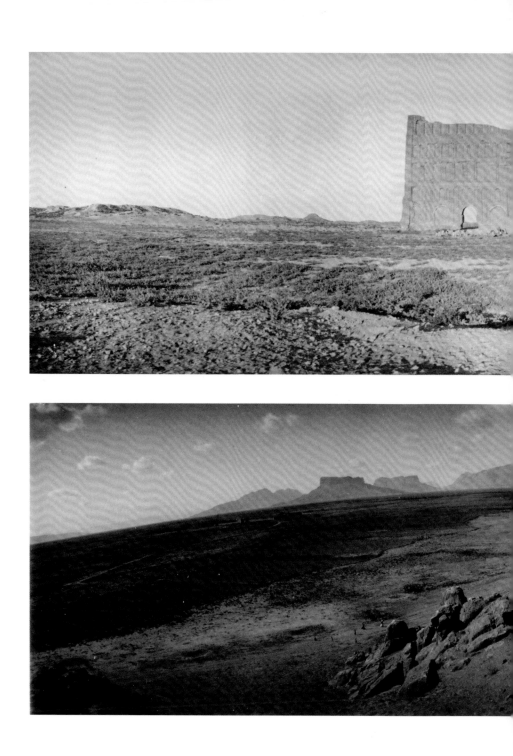

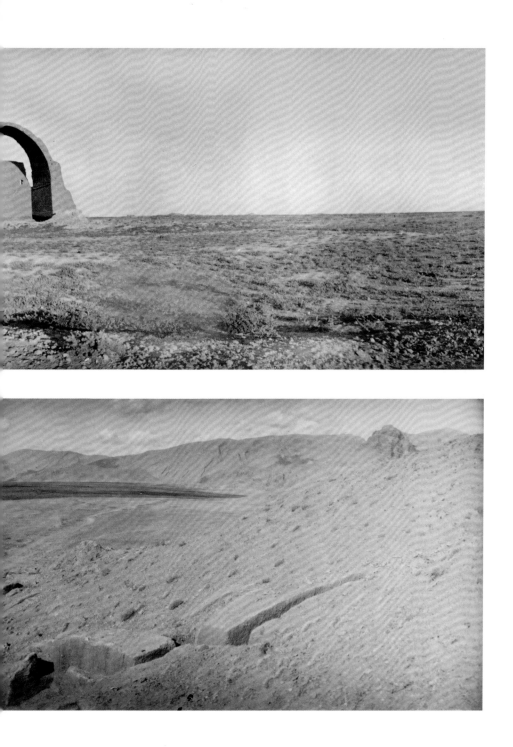

In late 1906, Freer made his first trip to Egypt, where he acquired the antiquities that form a small but intrinsically important part of the collections that he later bequeathed to the Smithsonian. Traveling up the Nile, he visited Luxor, Abydos, and Abu Simbel, and went as far as modern Sudan. By the turn of the century, quality photographs of ancient sites were available throughout the well-developed tourist routes that Freer followed. The twenty-six prints he acquired represent a good range of works by studios active in Egypt at the time, such as the preeminent **Maison Bonfils** (active 1867–early twentieth century). **Antonio Beato** (after 1832–1906), brother of Felice Beato, also maintained a studio in Luxor, where he sold views of Egyptian temples to tourists (see fig. 59).

79
Pylon on north side
Maison Bonfils
(act. 1867–early
20th century)
Karnak, Egypt, late
19th century
Albumen print,
27.7 × 21.5 cm
Charles Lang Freer
Papers
Freer|Sackler
Archives

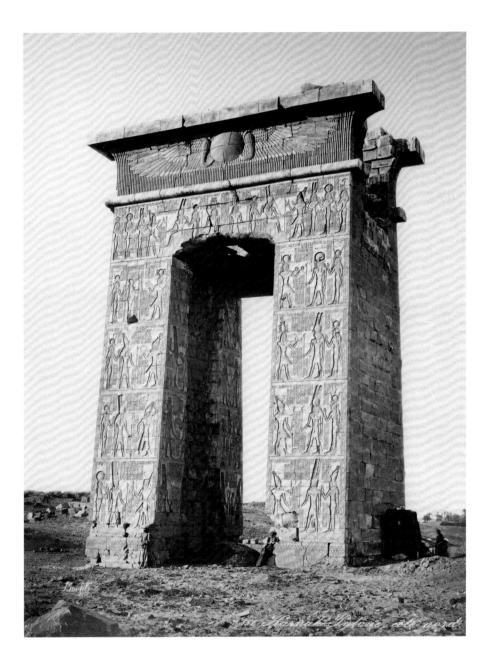

Freer visited the Middle East again in 1908 for a nearly month-long trip through Palestine, Lebanon, and Syria, where he acquired a striking set of collodion prints of Aleppo by an unknown photographer. With views of the city's famous citadel and grand mosque, such images are important documents of now-damaged sites, highlighting period photographs' secondary role of recording lost architectural heritage.

80
View of the minaret of the Grand Mosque
Unknown photographer
Aleppo, Syria, early 20th century
Collodion print, 24 × 17.8 cm
Charles Lang Freer Papers
Freer|Sackler Archives

81
next spread,
View toward the Citadel
Unknown photographer
Aleppo, Syria, early 20th century
Collodion print, 17.8 × 24 cm
Charles Lang Freer Papers
Freer|Sackler Archives

Freer's engagement with the camera deepened in 1910–11, when he took his final trip to Asia. Reflecting his growing fascination with ancient Chinese art, Freer spent more than five months in China to build his collection and explore ancient sites further inland. His main goal was to reach the Longmen grottoes in eastern Henan province, a quest clearly inspired by a volume of photographs of Longmen that noted sinologist Edouard Chavannes had published the previous year. No longer satisfied with studio prints marketed to tourists, Freer hired **Yütai** (active early twentieth century), a professional photographer who had a studio in Beijing and produced Chavannes' images, to document the site. Yütai accompanied Freer throughout the expedition and produced 160 glass plate negatives. Considering the cumbersome nature of cameras, glass plates, and developing equipment, the number of surviving photographs of such a remote site is extraordinary.

During his time at Longmen, Freer was appalled at the visible destruction caused by looting and neglect due to the worsening political situation in China. Several of Yütai's photographs are the only visual record of the original positions of sculptures and reliefs in the caves (fig. 85). Freer also brought his own portable film camera, producing snapshots of views and people that convey his enduring fondness for China (fig. 84).

82
Youguosi complex
Yütai (act. early
20th century)
Kaifeng, China, 1910
Glass plate negative,
21.4 × 16.3 cm
Charles Lang Freer
Papers
Freer|Sackler
Archives

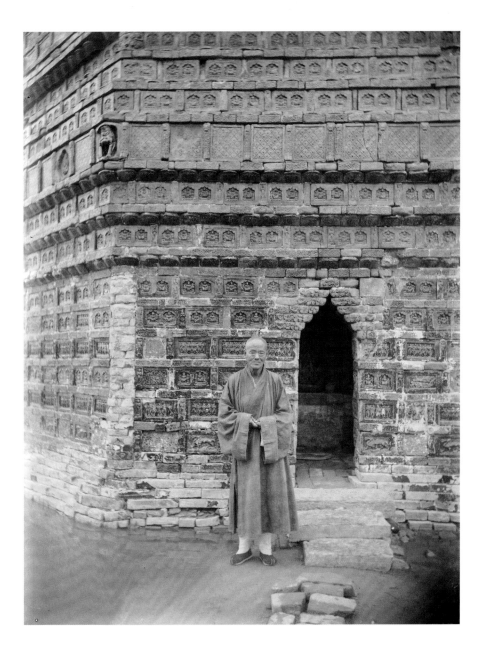

83
Youguosi complex
Yütai (act. early
20th century)
Kaifeng, China, 1910
Glass plate negative,
16.3 × 21.4 cm
Charles Lang Freer
Papers
Freer|Sackler
Archives

84
Porters at Yi River
Charles Lang Freer
(1854–1919)
Longmen, China, 1910
Gelatin silver print
from film negative,
17.5 × 13.3 cm
Charles Lang Freer
Papers
Freer|Sackler
Archives

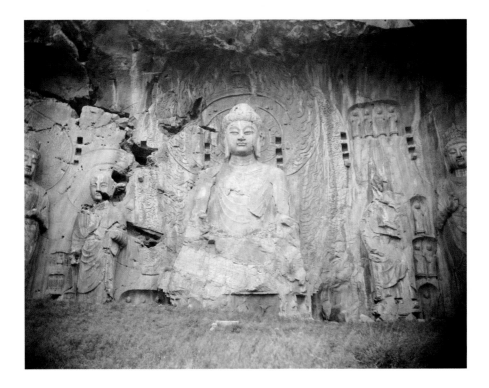

85
Fengxiansidong,
Central Buddha
Yūtai (act. early
20th century)
Longmen, China, 1910
Glass plate negative,
21.4 × 16.3 cm
Charles Lang Freer
Papers
Freer|Sackler
Archives

The following February, Freer made one more expedition, traveling by barge upriver from Shanghai to the ancient Southern Song capital of Hangzhou and the West Lake. He and a small party of friends explored the temples, gardens, and vistas of China's famed location, which frequently is depicted in the Japanese and Chinese paintings that Freer collected. Two hired photographers accompanied the group; of the images they captured, sixty-two plates survive.

86
Bridge on West Lake
Unknown
photographer
Hangzhou, China,
February 1911
Glass plate negative,
12.6 × 17.7 cm
Charles Lang Freer
Papers
Freer|Sackler
Archives

87
Charles Lang Freer
with Claire Dallam
at Zhusuyuan
Unknown
photographer
Hangzhou, China,
February 1911
Glass plate negative,
12.6 × 17.7 cm
Charles Lang Freer
Papers
Freer|Sackler
Archives

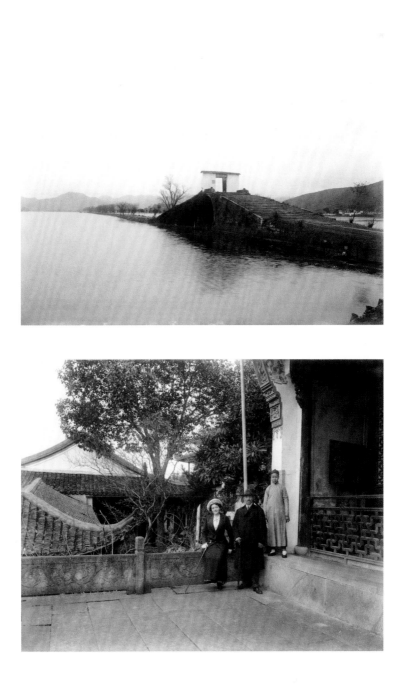

Like Freer, American photographer **Lois Conner** (born 1951) developed an interest in China and traveled there regularly. In 1984, she began photographing much of the country's natural and built environment with a large-format banquet camera. Inspired by the format and subject matter of Chinese scroll paintings, Conner's platinum prints are richly toned panoramic views of the country's vast and rapidly changing landscape.

Hehua (lotus), taken in Hangzhou decades after Freer was there, is from a series of lyrical abstractions composed of dying lotus plants, still water, and reflected sky. In *Yangshuo, Guangxi*, a lone figure stands in the middle of a massive construction site. The majestic mountainous landscape, a familiar feature in traditional views of China, fades into the background, obscured by a dense web of steel rods and concrete reaching toward the sky.

88
Hehua (lotus)
Lois Conner
(b. 1951, United States)
1995
Platinum print on vellum paper,
19.8 × 46.3 cm
Gift of the artist in memory of Alice Yang
Arthur M. Sackler Gallery,
S1997.145

89
Yangshuo, Guangxi
Lois Conner
(b. 1951, United States)
1993
Platinum print,
21.1 × 46.5 cm
Gift of Lois Conner in honor of her parents
Arthur M. Sackler Gallery,
S1995.76

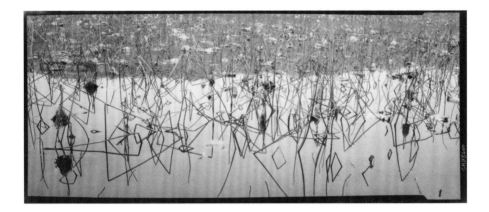

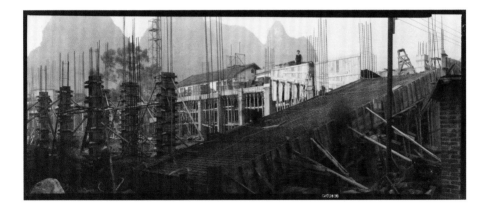

Hai Bo (born 1962) has been returning to his hometown in Jilin province, northeastern China, for more than two decades. In *Untitled No. 36*, a man crosses a bridge in a park where Hai Bo and his late brother played as children (fig. 91). The bridge is now gone, as the nearby city grows in the distant horizon. A solitary figure stands amidst overturned earth and denuded trees in *The Northern No. 14* and in the shadow of monumental concrete structures in the desolate plains in *Untitled No. 51* (fig. 92). The overwhelming scale of the surrounding environment, enveloped in a cold and gray light, reinforces the sense of absence and isolation. By observing the landscape of his youth over time, Hai Bo not only records environmental changes in this remote region, but he also evokes the impossibility of ever returning to the place of one's memories.

90
*The Northern No. 14
(Dense Fog)*
Hai Bo
(b. 1962, China)
2004
Inkjet print,
129.5 × 169.5 cm
Purchase—Friends of
the Freer and Sackler
Galleries
Arthur M. Sackler
Gallery,
S2011.9

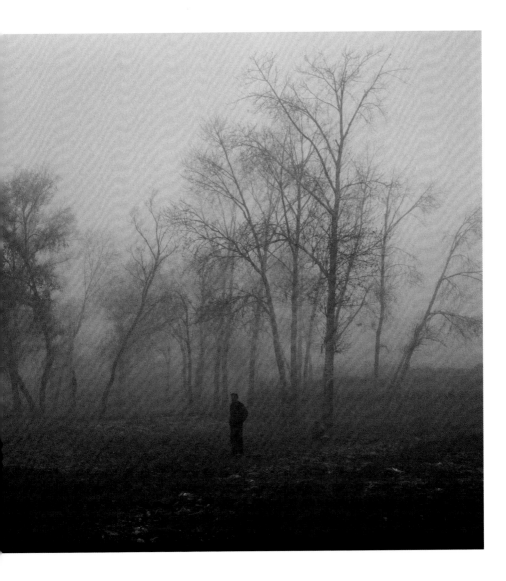

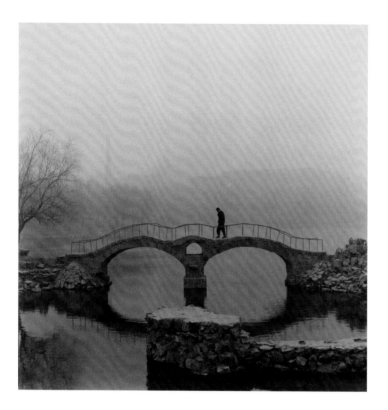

91
Untitled No. 36
Hai Bo
(b. 1962, China)
2001
Gelatin silver print,
67.9 × 66.7 cm
Purchase—Friends of
the Freer and Sackler
Galleries
Arthur M. Sackler
Gallery,
S2011.7

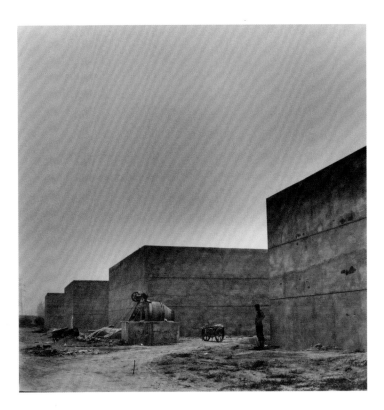

92
Untitled No. 51
Hai Bo
(b. 1962, China)
2003
Gelatin silver print,
67.9 × 66.7 cm
Purchase—Friends of
the Freer and Sackler
Galleries
Arthur M. Sackler
Gallery,
S2011.8

In the mid-1970s, **An-My Lê** (born 1960) and her family were forced to leave Vietnam and settle in the United States. These prints (figs. 93–97), part of an early series Lê created on multiple trips to Vietnam between 1994 and 1997, presage much of her work exploring the relationship between the representation of war and the natural landscape. The rhythms of daily life from North Vietnam to the Mekong Delta—a family watching television in the shade, farmers and flocks emerging from lush vegetation, and a child playing in a field—present a contrast to her memories of violence and war. Shot in black and white, Lê's images of the Vietnamese landscape question the ways in which personal memories and popular culture (in particular, movies, print, and news media) can shape perceptions of place and history.

93
Untitled (Hanoi, 1994)
An-My Lê
(b. 1960, Vietnam)
1994
Gelatin silver print,
33.5 × 47.8 cm
Purchase
Arthur M. Sackler
Gallery,
S1997.13

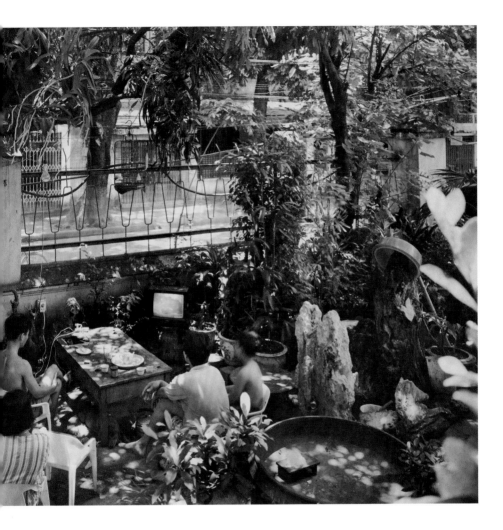

94
Untitled (Lap Vo, Delta of Mekong, 1995)
An-My Lê
(b. 1960, Vietnam)
1995
Gelatin silver print,
33.7 × 48 cm
Purchase
Arthur M. Sackler
Gallery,
S1997.15

95
*Untitled (Lap Vo, Delta
of Mekong, 1994)*
An-My Lê
(b. 1960, Vietnam)
1994
Gelatin silver print,
33.3 × 48 cm
Purchase
Arthur M. Sackler
Gallery,
S1997.14

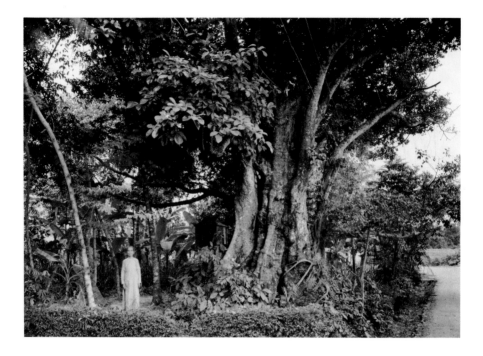

96
Untitled (Hue, 1994)
An-My Lê
(b. 1960, Vietnam)
1994
Gelatin silver print,
33.5 × 47.8 cm
Purchase
Arthur M. Sackler
Gallery,
S1997.16

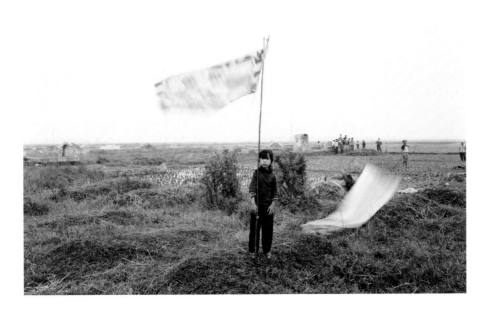

97
*Untitled (near Ninh
Binh, North Vietnam,
1995)*
An-My Lê
(b. 1960, Vietnam)
1995
Gelatin silver print,
40.5 × 50.4 cm
Purchase
Arthur M. Sackler
Gallery,
S1997.17

In the late 1980s, contemporary photographer and filmmaker **Seifollah Samadian** (born 1954) began documenting rural Iran and the social and economic impact of a lengthy war with Iraq. In three subtly dynamic shots (figs. 98–100), he observes two fishermen by the Caspian Sea, a young boy at a pottery factory in an Azerbaijan village, and children playing in the suburbs outside Tehran. The straightforward treatment of mundane activities belies the tension inherent in each composition. Whether shaving in the middle of overturned earth, climbing over a precarious mountain of pots, or playing among the detritus of war in a barren landscape, each figure seems suspended at the precipice of danger. The blank sky in each scene reinforces the oppressive atmosphere.

98
An Iranian fisherman being shaved by his colleague in a local fishing co-operative
Seifollah Samadian
(b. 1954, Iran)
1990
Inkjet print,
50 × 75 cm
Purchase—
Jahangir and
Eleanor Amuzegar
Endowment for
Contemporary
Iranian Art
Arthur M. Sackler
Gallery,
S2011.14

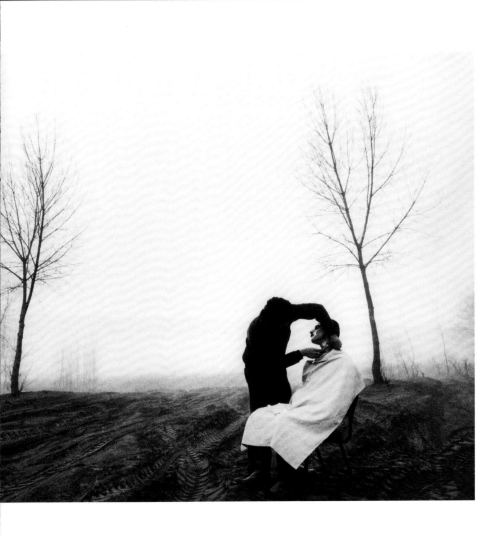

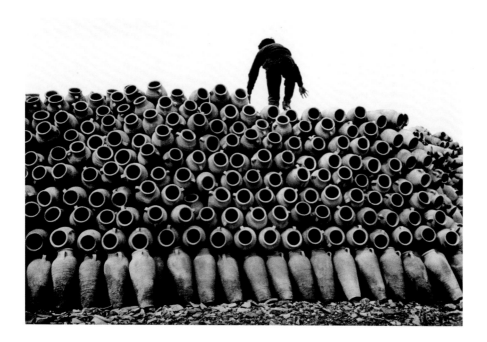

99
*A young boy helping
his father in their local
pottery factory*
Seifollah Samadian
(b. 1954, Iran)
1989
Inkjet print,
50 × 75 cm
Purchase—
Jahangir and
Eleanor Amuzegar
Endowment for
Contemporary
Iranian Art
Arthur M. Sackler
Gallery,
S2011.15

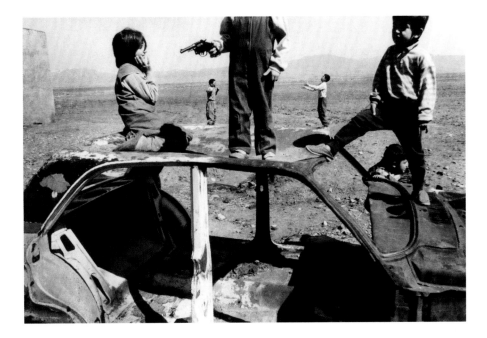

100
*The Iraq-Iran war
is over, but still
continues in the
games of children!*
Seifollah Samadian
(b. 1954, Iran)
1990
Inkjet print,
50 × 75 cm
Purchase—
Jahangir and
Eleanor Amuzegar
Endowment for
Contemporary
Iranian Art
Arthur M. Sackler
Gallery,
S2011.13

Trained initially as a painter and renowned for his films, **Abbas Kiarostami** (1940–2016) began photographing in the 1970s and frequently traveled throughout Iran observing the landscape. By capturing views that evoke a sense of awe and of the universality of nature, he ultimately sought to bring filmmaking closer to his photography and free his images from the burden of storytelling.[3] In these two works, mountain landscapes mark the passage of the seasons. Undulating bands of earth and golden light or the sharp contrast of snow against dark rock reveal a pristine world absent of any human presence. Kiarostami's images, typically untitled, engage the viewer without referring to any particular place or historical moment.

101
Untitled
Abbas Kiarostami
(1940–2016)
1997
Color print,
20.3 × 30.4 cm
Anonymous gift in
memory of
Philip L. Ravenhill
Arthur M. Sackler
Gallery,
S1999.124

102
next spread
Untitled
Abbas Kiarostami
(1940–2016)
1998
Color print,
20.3 × 30.4 cm
Anonymous gift in
memory of
Philip L. Ravenhill
Arthur M. Sackler
Gallery,
S1999.125

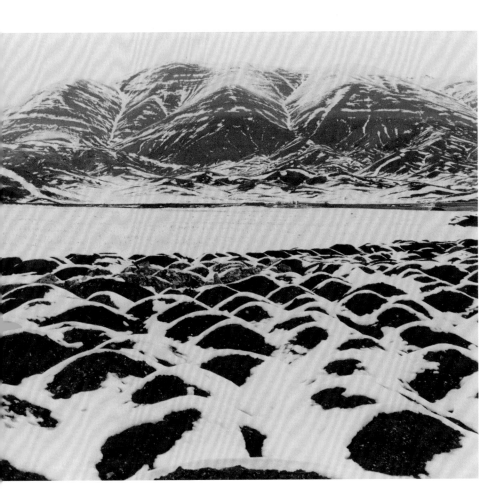

Both **Lynn Davis** (born 1944) and **Georg Gerster** (born 1928) turn archaeological remains into form and light. These two mammoth prints by Davis are part of the series Ancient Sites, taken during her travels in the late 1980s and 1990s to Yemen, Syria, Lebanon, Jordan, Egypt, and Turkey. Isolated in the center of each composition and shot from ground level, a minaret and an eighth-century palace become monumental forms. Collaborating with a master printer, Davis bleached and redeveloped the images several times to manipulate their tonalities, transforming the crumbling structures into luminous volumes in an austere landscape.

Inspired by archaeologist Erich Schmidt's extensive aerial surveys during the mid-1930s of sites in Iran, Gerster undertook more than one hundred flights from April 1976 to May 1978. He sought to expand upon Schmidt's project by shooting additional sites and views in color. In an image taken directly above the tomb of Cyrus the Great (fig. 105), the absence of a horizon or broader view of the landscape renders this ancient site as an abstract composition of shape, texture, and shadow. For Gerster, the aerial perspective not only reveals invaluable topographical information, but it also fosters deeper appreciation for the environment and humankind's place within it.

103
Palace, Syria, 1995
Lynn Davis (b. 1944,
United States)
1995
Selenium toned
gelatin silver print,
114.3 × 114.7 cm
Purchase
Arthur M. Sackler
Gallery,
S1997.22

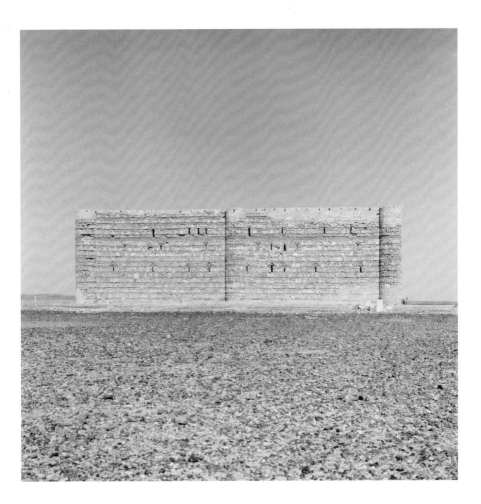

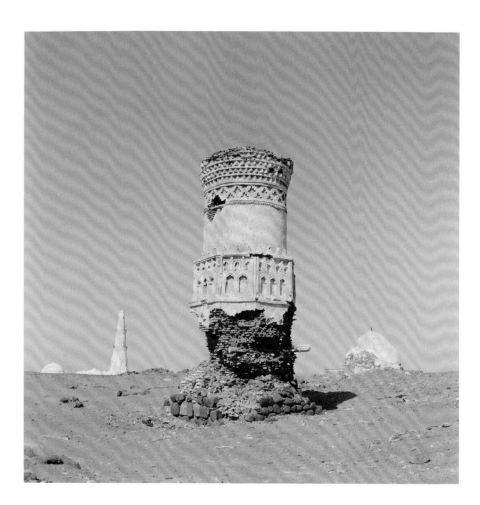

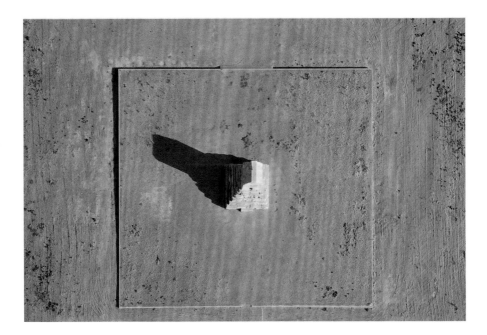

104
Minaret at Mocha,
Yemen, 1996
Lynn Davis (b. 1944,
United States)
1996
Selenium toned
gelatin silver print,
101.3 × 101.9 cm
Purchase
Arthur M. Sackler
Gallery,
S1997.23

105
The Tomb of Cyrus
the Great
Georg Gerster
(b. 1928, Switzerland)
1976
Inkjet print,
32 × 49 cm
Gift of Prince Reza
and Princess Yasmine
Pahlavi, Potomac, MD
Arthur M. Sackler
Gallery,
S2014.8

Sugimoto Hiroshi's (born 1948) ongoing Seascapes series makes palpable the luminous and primitive quality of the natural landscape. Begun in 1980, the series depicts sites throughout the world, including Germany's Boden Sea, the Black Sea from the shores of Turkey, and the Yellow Sea from Cheju Island in South Korea. Regardless of location, the composition and point of view remain constant. Varying bands of gray result in aesthetic, rather than topographical, treatments that record both the tonal range of black-and-white photography and the physical reality of natural light. Using long exposure times, Sugimoto turns sea and sky into mesmerizing representations of surface movement and atmosphere. By repeating these compositional devices in each image, he eliminates distracting details of specific places and heightens the viewer's perception of the photographs themselves.

106
Boden Sea / Utwill
Sugimoto Hiroshi
(b. 1948, Japan)
1993
Gelatin silver print,
42.4 × 54.3 cm
Purchase
Arthur M. Sackler
Gallery,
S1994.7

107
next spread
Black Sea / Ozuluce
Sugimoto Hiroshi
(b. 1948, Japan)
1991
Gelatin silver print,
42.3 × 54.2 cm
Purchase
Arthur M. Sackler
Gallery,
S1994.8

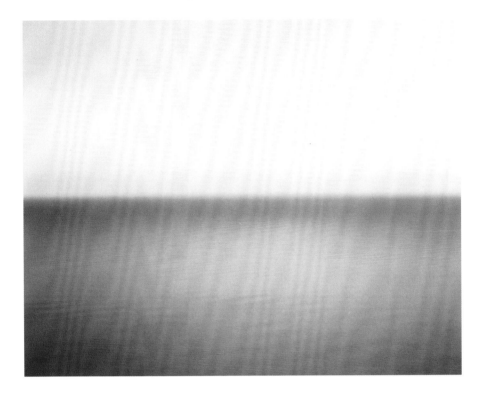

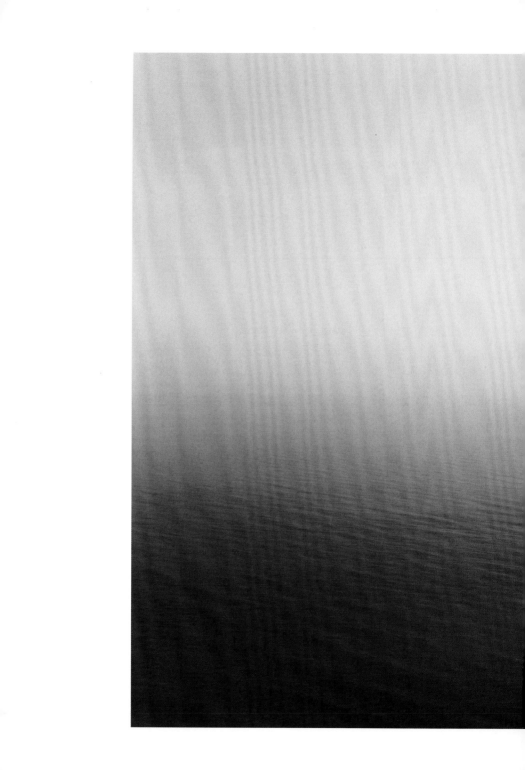

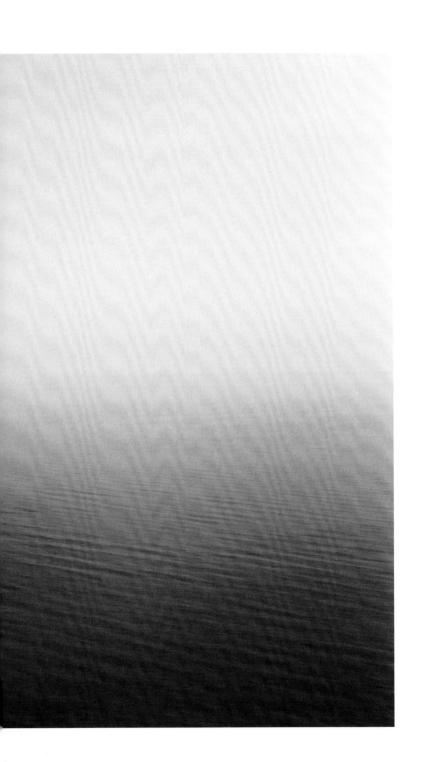

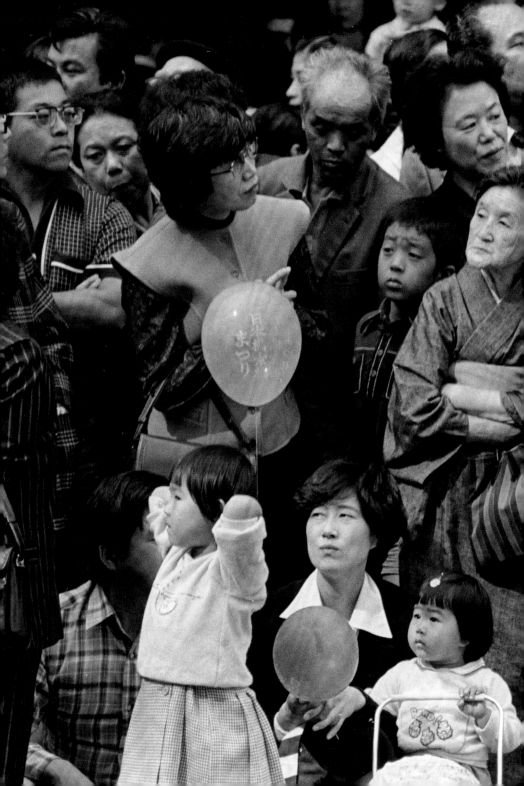

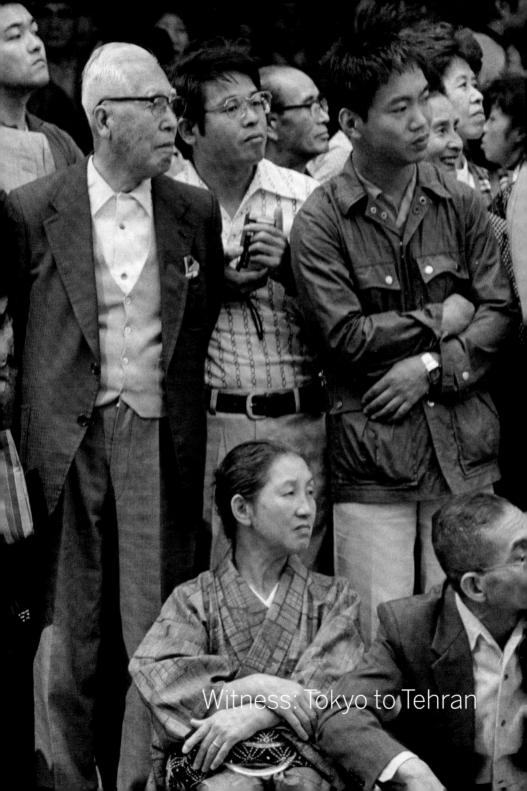

Witness: Tokyo to Tehran

"Actual experiments in time, actual experiments in space exactly suit a postwar state of mind," wrote American photographer Walker Evans in 1931. "The camera doing both, it is not surprising that photography has come to a valid flowering—the third period of its history."[4] In the early twentieth century, the camera promised powerful new ways of perceiving a modern world marked by the trauma of war and profound technological and urban change. Photographers embraced and challenged the medium's unique capacity to capture reality. Candid, composed, or abstracted, their images and attention to the evolving social landscape led to the flourishing of documentary photography that continues today.

The following selection of works highlights key moments in the development of photography in Japan, Iran, and India during the latter half of the twentieth century. Photographers and critics in postwar Japan questioned the nature and purpose of documentary photography and ignited radical experimentation with composition and subject matter. Images of Iran's political turmoil in the late 1970s brought worldwide attention to Iranian photographers and lay the foundations for a vigorous field of contemporary practice. Raghubir Singh drew on his lifelong interest in India and the expressiveness of color film to form a large body of work, offering vibrant glimpses of daily life in a modernizing country. Expanding the collection in new directions, the Freer|Sackler recently added works by Jeddah-based artist Ahmed Mater that address the shifting social and urban conditions in Saudi Arabia.

108
previous spread
Tokyo, 1981
From the series
Counting Grains of
Sand 1976–1989
Tsuchida Hiromi
(b. 1939, Fukui
Prefecture, Japan)
1981
Gelatin silver print,
27.9 × 35.7 cm
Purchase—Friends of
the Freer and Sackler
Galleries
Arthur M. Sackler
Gallery, S2013.16

109
facing page
Nature Morte
From the series
Desert of Pharan
Ahmed Mater
(b. 1979, Saudi Arabia)
2013
Laserchrome print,
119.4 × 123.2 cm
Purchase—Friends of
the Freer and Sackler
Galleries
Arthur M. Sackler
Gallery, S2014.6

Japan

The city of Tokyo has been an enduring subject in Japanese art and fertile ground for photographic experimentation. **Kitadai Shozo** (1921–2001) was a key member of Jikken Kobo (Experimental Workshop), a collective of artists, writers, choreographers, composers, and engineers that collaborated across disciplines in an attempt to develop a new artistic language. For some of his earliest photographs, Kitadai worked with fellow artist **Otsuji Kiyoji** (1923–2001) to create and shoot sculptural constructions exploring the interplay of light and dark. He also joined the short-lived Japan Subjective Photography League and developed a style that favored abstracted compositions and closeup shots.

Kitadai's Form series, dating from the mid- to late 1950s, transforms modern and traditional architectural forms in Tokyo into sweeping lines, deep voids, and sharp tonal contrasts (figs. 110–14). The picture plane in *Form 14* (fig. 114) is filled with the dark weight of a wall and, with a nod to Jikken Kobo's theatrical activities, introduces the unusual element of a harlequin-patterned figure (Hideko Fukushima, the only female member of the group). Kitadai extracts fragments from the built world around him, distilling them into shapes and volumes of light enhanced by an attention to print quality that was unusual among Japanese photographers at the time.

Hamaguchi Takashi (born 1931) focused on major social movements to better understand postwar Japan. He gained recognition for his work in the 1960s and 1970s, shooting student protests, reactions to American military bases, and farmers' demonstrations against the construction of Narita Airport. Prints in the museum's collection capture student-led demonstrations in Tokyo, the epicenter of the movement. From the ratification of the ANPO treaty between Japan and the United States in 1960 to its renewal in 1970, Hamaguchi witnessed violent events in the Shinjuku neighborhood (fig. 115), the assault on Tokyo University (figs. 116–17), and the Kanda Liberation Zone riots (fig. 118). The last image in this group was taken amid a brief respite, as police and protesters maintained a cease-fire during a memorial service for a student killed in the first ANPO protests (fig. 119). Beyond simply recording these

moments, Hamaguchi captures the hot flash of destruction, thick smoke of chaos, patient defiance, and tension of a gesture hanging in space.

Moriyama Daido (born 1938) also drew inspiration from the intense social and cultural ferment of a rapidly changing Japan. He emerged as the most recognized of a group of photographers that published the short-lived yet highly influential journal *Provoke*. Launched in 1968, *Provoke* advocated a radical departure from straight documentary and developed a distinctive high-contrast, grainy, and blurry style, which Moriyama effectively used to convey the agitated, gritty atmosphere of Japanese street life. His technique of shooting from an unusual perspective, as if the camera were a part of his body, and his tendency toward oblique views are apparent in *Yumenoshima* (fig. 120). This area of reclaimed land in Tokyo Bay was used as a landfill throughout the 1970s before being transformed into "Dream Island" in the late 1980s. Similarly, in *Tokyo*, the limp profile of a woman in Shinjuku tilts oddly, as if the city's jagged landscape were tumbling forward under her feet (fig. 123).

In his 1966 photo *Computer Age*, Moriyama imparts a lifeless uniformity to a group of men. They are portrayed as featureless components in the artificial glare of computers and fluorescent lights, and the cold reflections of synthetic surfaces (fig. 121). Similarly, gashes of light illuminate two officers in a coffee shop as they look casually at the camera, and a waitress stares blankly at the counter that rakes diagonally across the composition (fig. 122). In *Cherry Blossoms* from 1982, sharp contrast and tight framing give an ominous, almost suffocating air to a blooming tree (fig. 124). Electrical wires and buildings hovering in the image's dark edges further subvert this archetypal element of the Japanese landscape.

Born in 1939, **Tsuchida Hiromi**'s views of daily life in Japan are likewise steeped in the pressures and paradoxes of a modernizing country, albeit in a less confrontational style. From 1976 to 1989, he produced the series Counting Grains of Sand, comprising more than seventy photographs taken in and around Tokyo—a region in which economic growth and rapid urbanization contributed to

extraordinary population density. In the five images included here, public spaces become stages for observing crowds of people. Hunched over games of shogi (a form of chess), men pay little attention to the folk dancers in the background (fig. 125). Performing on the slightly askew concrete stage, the dancers seem like incongruous remnants of a more traditional world. At a graduation ceremony at the National Defense Academy in Yokosuka, a woman waiting by the side of the road stares blankly to the right with the muted sense of expectation and boredom that can accompany large public ceremonies (fig. 126).

Tsuchida's image of a crowd watching a parade at Nihonbashi is anchored in the center by an elderly couple; the two gaze in opposite directions while those surrounding them appear mildly interested in the festivities (fig. 127). Faces under a busy sea of hats and flags reinforce the uniformity of people celebrating May Day under the bright Tokyo sun (fig. 128). At a summer concert at the Oiso Prince Hotel in Kanagawa, a seemingly improbable wall of people fills Tsuchida's extraordinary portrait of a growing middle class and its leisure activities (fig. 129). Throughout these photographs, the dense compositions, tension between the overwhelming mass and individual faces, and focal points placed somewhere outside the frame embody the sense of anonymity and disorientation that characterizes modern urban life.

110
Form 1
Kitadai Shozo
(1921–2001)
1956
Gelatin silver print,
27.8 × 35.5 cm
Purchase—Friends of
the Freer and Sackler
Galleries and General
Collection Acquisition
Fund
Arthur M. Sackler
Gallery, S2015.8

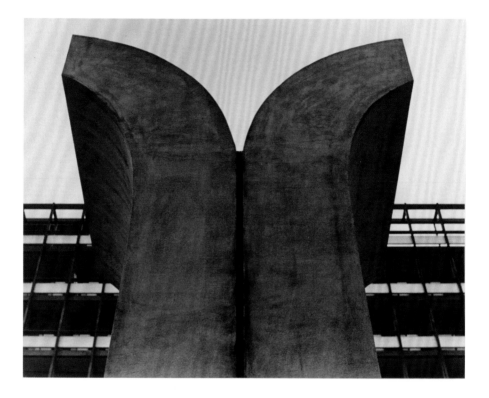

111
Form 2
Kitadai Shozo
(1921–2001)
1957
Gelatin silver print,
27.8 × 35.5 cm
Purchase—Friends of
the Freer and Sackler
Galleries and General
Collection Acquisition
Fund
Arthur M. Sackler
Gallery, S2015.9

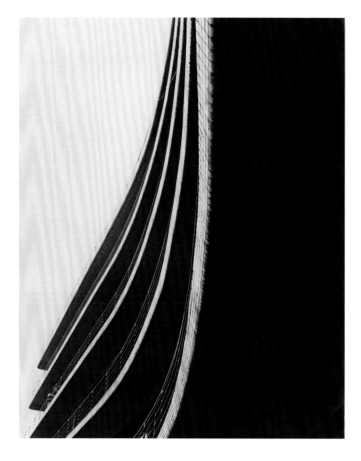

112
Form 5
Kitadai Shozo
(1921–2001)
1956
Gelatin silver print,
35.5 × 27.8 cm
Purchase—Friends of
the Freer and Sackler
Galleries and General
Collection Acquisition
Fund
Arthur M. Sackler
Gallery, S2015.10

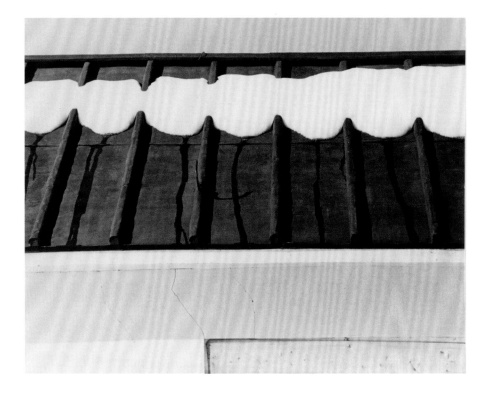

113
Form 7
Kitadai Shozo
(1921–2001)
1957
Gelatin silver print,
27.8 × 35.5 cm
Purchase—Friends of
the Freer and Sackler
Galleries and General
Collection Acquisition
Fund
Arthur M. Sackler
Gallery, S2015.11

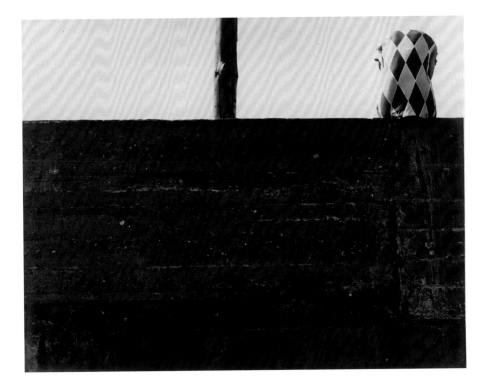

114
Form 14
Kitadai Shozo
(1921–2001)
1960
Gelatin silver print,
27.8 × 35.6 cm
Purchase—Friends of
the Freer and Sackler
Galleries and General
Collection Acquisition
Fund
Arthur M. Sackler
Gallery, S2015.12

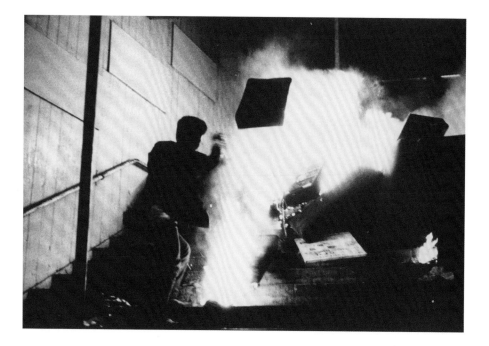

115
October 21, 1968,
Anti-War Day,
Shinjuku Incident,
Tokyo
Hamaguchi Takashi
(b. 1931, Japan)
1968
Gelatin silver print,
23 × 33.3 cm
Purchase—Friends of
the Freer and Sackler
Galleries
Arthur M. Sackler
Gallery, S2016.8.1

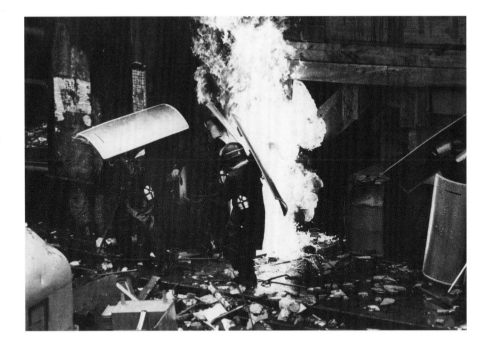

116
January 18, 1969,
Tokyo University,
Tokyo, Yasuda Hall
Hamaguchi Takashi
(b. 1931, Japan)
1969
Gelatin silver print,
22.9 × 33.3 cm
Purchase—Friends of
the Freer and Sackler
Galleries
Arthur M. Sackler
Gallery, S2016.8.2

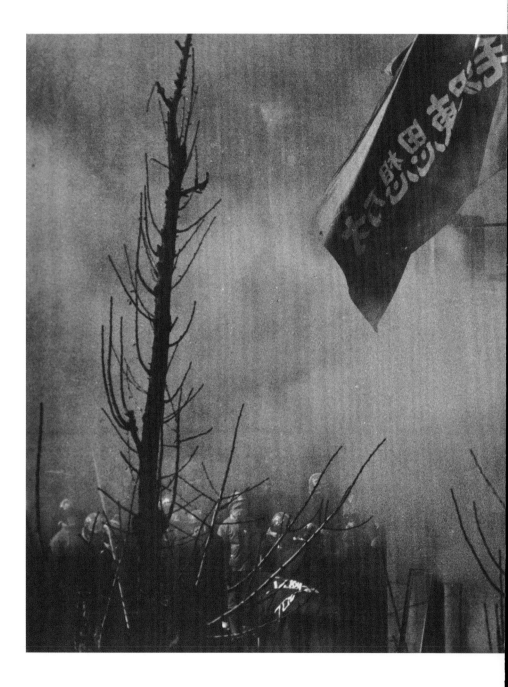

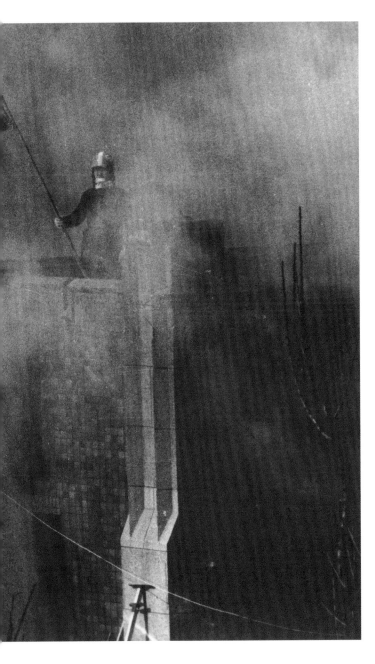

117
January 18, 1969,
Tokyo University,
Tokyo, The Faculty of
Engineering building
(Reppin-kan)
Hamaguchi Takashi
(b. 1931, Japan)
1969
Gelatin silver print,
22.9 × 33.4 cm
Purchase—Friends of
the Freer and Sackler
Galleries
Arthur M. Sackler
Gallery, S2016.8.3

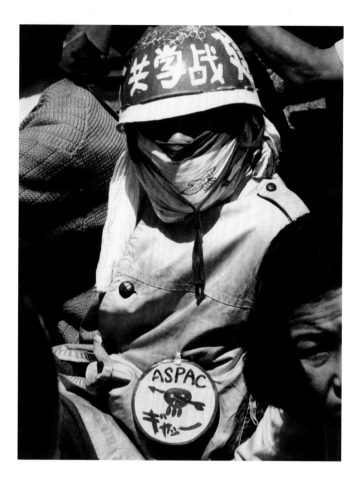

118
1969, Kanda-Ochanomizu, Tokyo
Hamaguchi Takashi
(b. 1931, Japan)
1969
Gelatin silver print,
30 × 22.7 cm
Purchase—Friends of
the Freer and Sackler
Galleries
Arthur M. Sackler
Gallery, S2016.8.4

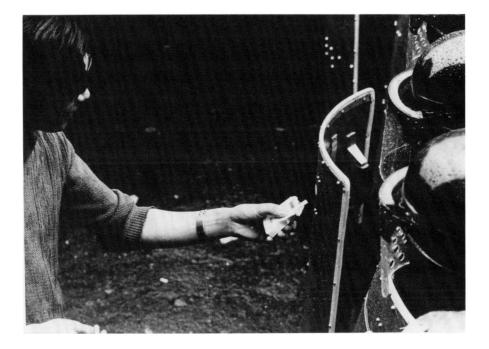

119
*June 15, 1969, Hibiya
Park, Tokyo*
Hamaguchi Takashi
(b. 1931, Japan)
1969
Gelatin silver print,
23 × 33.4 cm
Purchase—Friends of
the Freer and Sackler
Galleries
Arthur M. Sackler
Gallery, S2016.8.5

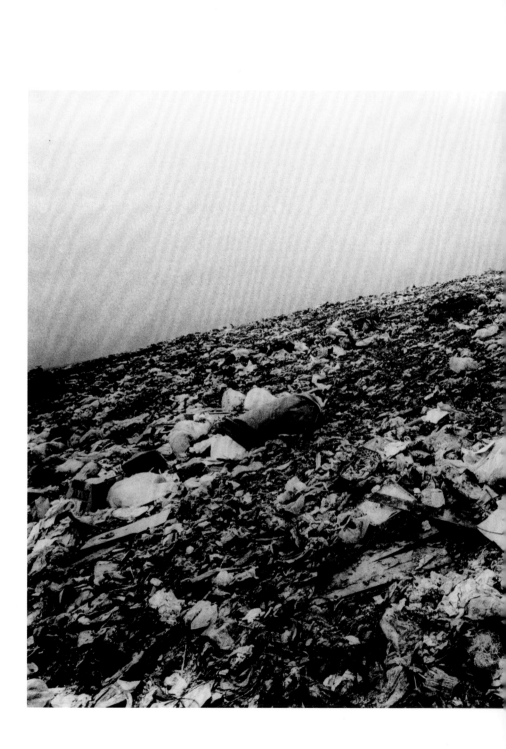

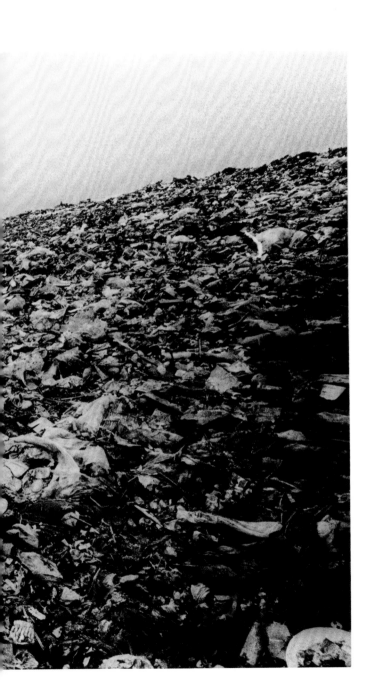

120
Yumenoshima
Moriyama Daido
(b. 1938, Ikeda City,
Japan)
1966
Gelatin silver print,
26.4 × 38.6 cm
Purchase—Friends of
the Freer and Sackler
Galleries
Arthur M. Sackler
Gallery, S2012.11

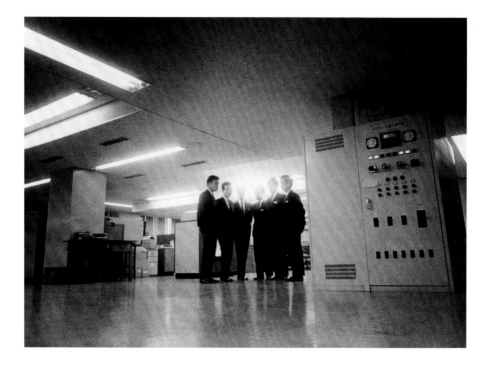

121
Computer Age
Moriyama Daido
(b. 1938, Ikeda City,
Japan)
1966
Gelatin silver print,
25.4 × 30.5 cm
Purchase—Friends of
the Freer and Sackler
Galleries
Arthur M. Sackler
Gallery, S2012.14

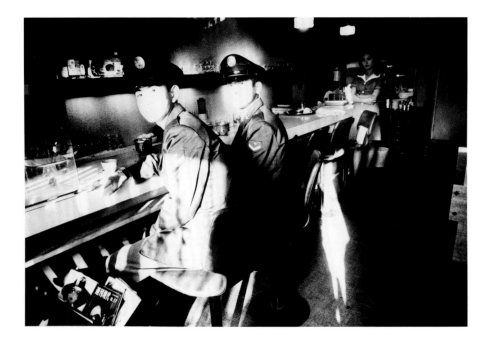

122
Coffee Shop,
Hamamatsu
Moriyama Daido
(b. 1938, Ikeda City,
Japan)
1968
Gelatin silver print,
20.2 × 29.7 cm
Purchase—Friends of
the Freer and Sackler
Galleries
Arthur M. Sackler
Gallery, S2012.12

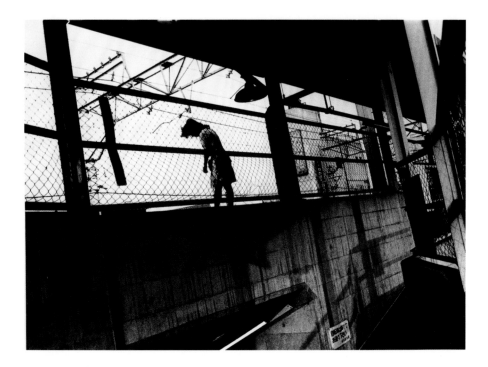

123
Tokyo
Moriyama Daido
(b. 1938, Ikeda City,
Japan)
1980
Gelatin silver print,
21.2 × 29.6 cm
Purchase—Friends of
the Freer and Sackler
Galleries
Arthur M. Sackler
Gallery, S2012.13

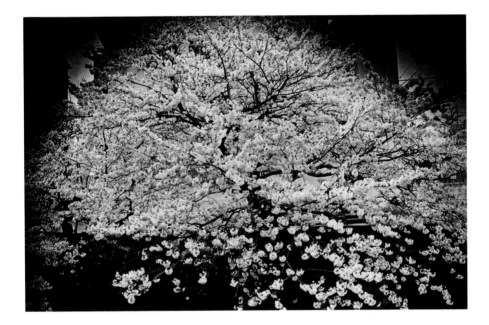

124
Cherry Blossoms
Moriyama Daido
(b. 1938, Ikeda City,
Japan)
1982
Gelatin silver print,
27.7 × 35.9 cm
Purchase—Friends of
the Freer and Sackler
Galleries
Arthur M. Sackler
Gallery, S2012.10

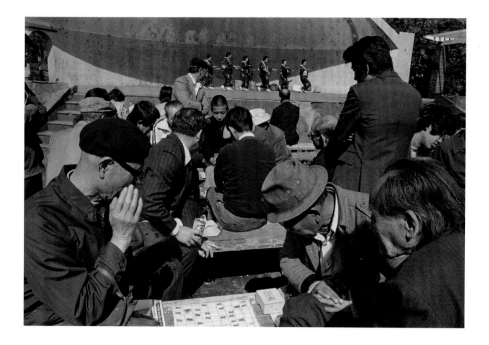

125
Tokyo, 1981
From the series
Counting Grains of
Sand 1976–1989
Tsuchida Hiromi
(b. 1939, Fukui
Prefecture, Japan)
1981
Gelatin silver print,
27.9 × 35.7 cm
Purchase—Friends of
the Freer and Sackler
Galleries
Arthur M. Sackler
Gallery, S2013.15

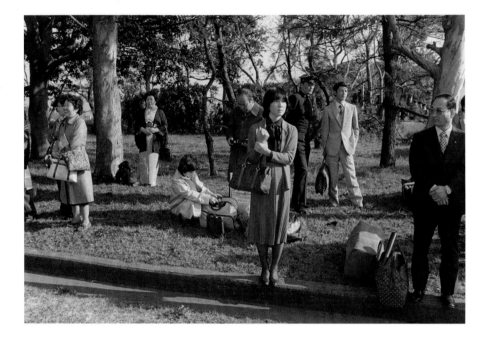

126
Tokyo, 1981
From the series
Counting Grains of
Sand 1976–1989
Tsuchida Hiromi
(b. 1939, Fukui
Prefecture, Japan)
1981
Gelatin silver print,
27.9 × 35.7 cm
Purchase—Friends of
the Freer and Sackler
Galleries
Arthur M. Sackler
Gallery, S2013.17

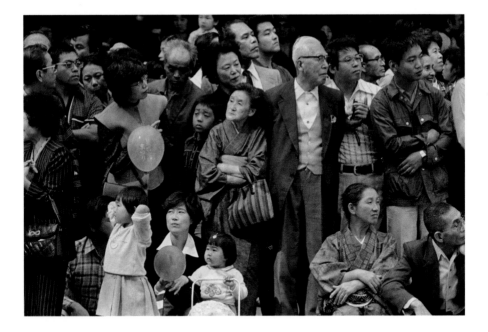

127
Tokyo, 1981
From the series
Counting Grains of
Sand 1976–1989
Tsuchida Hiromi
(b. 1939, Fukui
Prefecture, Japan)
1981
Gelatin silver print,
27.9 × 35.7 cm
Purchase—Friends of
the Freer and Sackler
Galleries
Arthur M. Sackler
Gallery, S2013.16

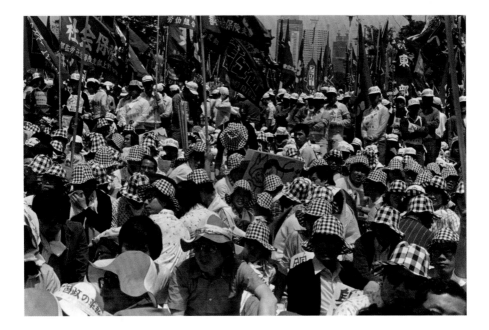

128
Tokyo, 1976
From the series
Counting Grains of
Sand 1976–1989
Tsuchida Hiromi
(b. 1939, Fukui
Prefecture, Japan)
1976
Gelatin silver print,
27.9 × 35.7 cm
Purchase—Friends of
the Freer and Sackler
Galleries
Arthur M. Sackler
Gallery, S2013.14

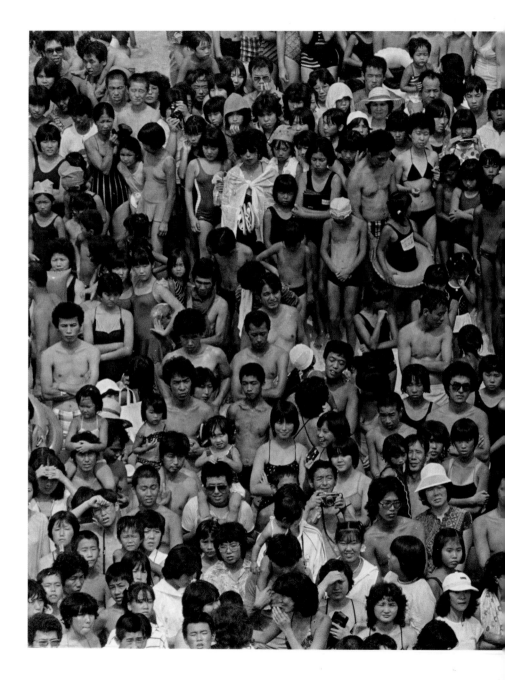

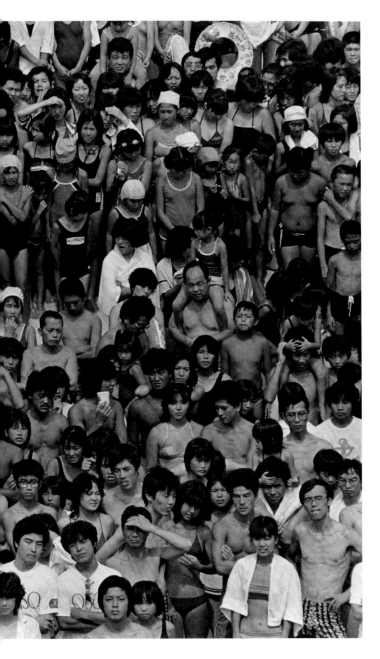

129
Oiso, 1981
From the series
Counting Grains of
Sand 1976–1989
Tsuchida Hiromi
(b. 1939, Fukui
Prefecture, Japan)
1981
Gelatin silver print,
27.9 × 35.7 cm
Purchase—Friends of
the Freer and Sackler
Galleries
Arthur M. Sackler
Gallery, S2013.18

Iran

Documentary photographs in the Freer|Sackler's collection by **Bahman Jalali**, Rana Javadi, and Hengameh Golestan bear witness to a seminal period in modern Iran. Jalali (1945–2010) spent much of his career documenting the impact of political, economic, and environmental change on Iranian society. Like a modern-day Antoin Sevruguin (see page 33), he produced extensive visual essays on the country, addressing the scars of the Iran-Iraq War (1980–88), the conditions of fishermen in the Persian Gulf and Caspian Sea, and the architecture of Iran's desert cities.

While Jalali's Image of Imagination series (see page 38) appropriates photographic history, his earlier series Days of Blood, Days of Fire captures history in the making—specifically, the revolution in Iran, from the first demonstrations in 1978 to the end of the regime in 1979. Among the many tightly composed street shots of individuals and bursts of violence, one rare wide-angle view depicts a demonstration in front of Tehran University (fig. 130). This image of a broad avenue overflowing with people exudes the immense power and tense expectation of a society in the throes of transformation.

Rana Javadi (born 1953), wife of Bahman Jalali and a photographer in her own right, contributed to Days of Blood, Days of Fire. In one of her images, a crowd has gathered in the street outside a ransacked police station in Tehran. Heads bent, people stand reading papers picked up from the ankle-deep piles covering the ground (fig. 131). The white sheets of paper, strewn like confetti over the sidewalk and hanging from the trees, make palpable the heady atmosphere of revolution in its early days.

Born in 1952, **Hengameh Golestan** is another of Iran's very few known female photographers active in the immediate post-revolutionary period. She took to the streets during a major demonstration on March 8–11, 1979, in response to Ayatollah Ruhollah Khomeini's decree requiring women to wear a veil in public. The resulting series, Witness 1979, captures the last day that Iranian women were photographed in public en masse

without the veil, as well as the first widespread vocal protest of the Ayatollah Khomeini since his return. This selection of images (figs. 132–38) highlights the mood and experience of the time, noting the support of some men, including clerics, and the determination of individual protestors as their voices filled the streets. Wider views of crowds marching with their umbrellas under snowy skies resonate with the solidarity and hopefulness present in these early revolutionary days, and just before the protest's tragic end, when people were beaten in the streets.

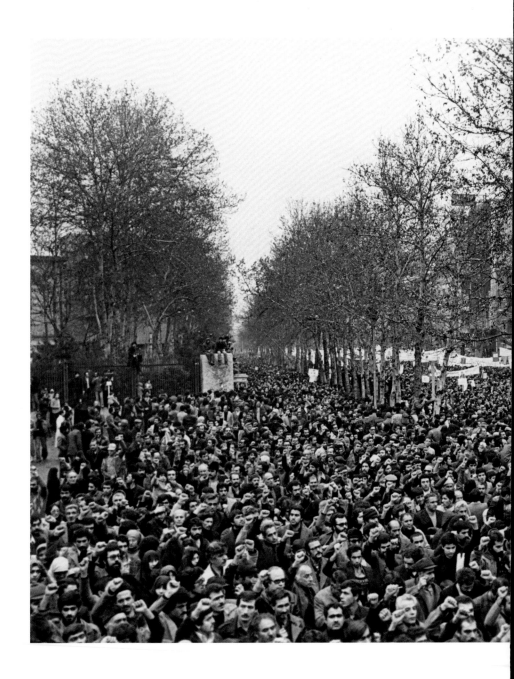

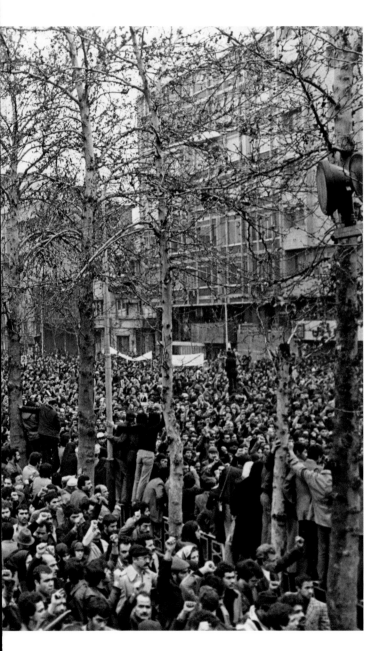

130
Untitled
From the series Days
of Blood, Days of Fire
Bahman Jalali
(1945–2010)
1978
Inkjet print,
45 × 60 cm
Gift of Rana Javadi
Arthur M. Sackler
Gallery, S2014.13

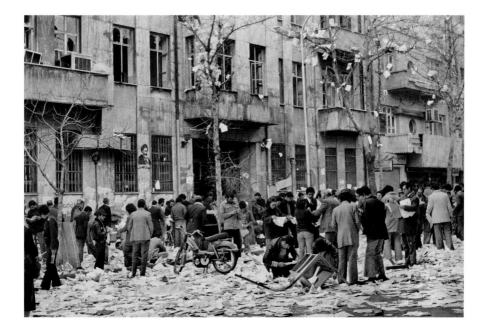

131
Untitled
From the series Days
of Blood, Days of Fire
Rana Javadi
(b. 1953, Iran)
1978
Inkjet print,
45 × 60 cm
Purchase—
Jahangir and
Eleanor Amuzegar
Endowment for
Contemporary
Iranian Art
Arthur M. Sackler
Gallery, S2014.12

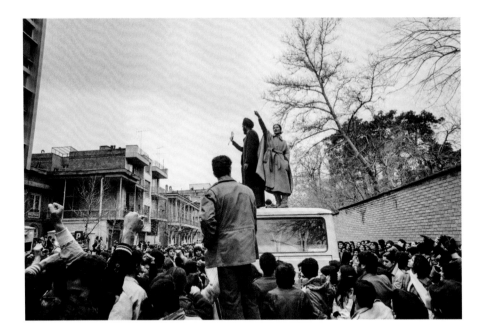

132
Untitled
From the series
Witness 1979
Hengameh Golestan
(b. 1952, Iran)
1979
Inkjet print,
30.1 × 45.1 cm
Purchase—
Jahangir and
Eleanor Amuzegar
Endowment for
Contemporary
Iranian Art
Arthur M. Sackler
Gallery, S2015.21

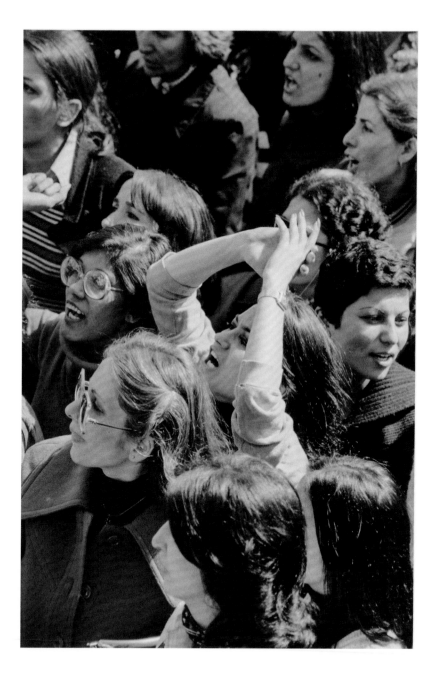

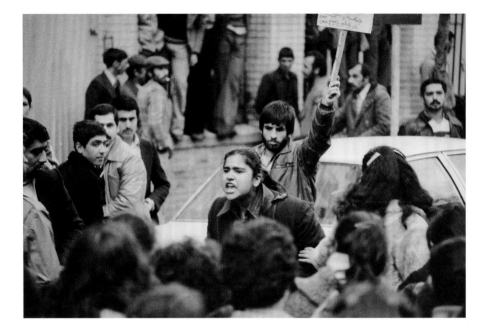

133
Untitled
From the series
Witness 1979
Hengameh Golestan
(b. 1952, Iran)
1979
Inkjet print,
45.1 × 30.1 cm
Purchase—
Jahangir and
Eleanor Amuzegar
Endowment for
Contemporary
Iranian Art
Arthur M. Sackler
Gallery, S2015.22

134
Untitled
From the series
Witness 1979
Hengameh Golestan
(b. 1952, Iran)
1979
Inkjet print,
30.1 × 45.1 cm
Purchase—
Jahangir and
Eleanor Amuzegar
Endowment for
Contemporary
Iranian Art
Arthur M. Sackler
Gallery, S2015.23

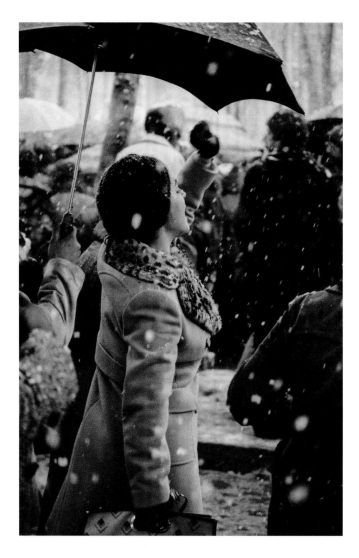

135
Untitled
From the series
Witness 1979
Hengameh Golestan
(b. 1952, Iran)
1979
Inkjet print,
45.1 × 30.1 cm
Purchase—
Jahangir and
Eleanor Amuzegar
Endowment for
Contemporary
Iranian Art
Arthur M. Sackler
Gallery, S2015.17

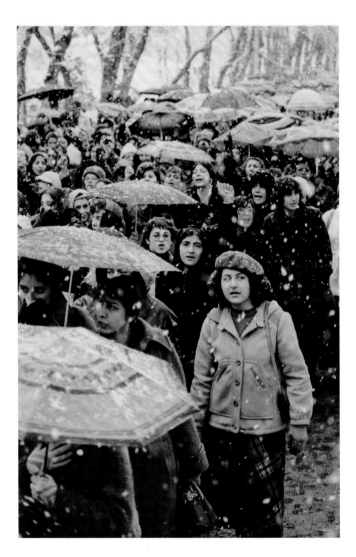

136
Untitled
From the series
Witness 1979
Hengameh Golestan
(b. 1952, Iran)
1979
Inkjet print,
45.2 × 30.1 cm
Purchase—
Jahangir and
Eleanor Amuzegar
Endowment for
Contemporary
Iranian Art
Arthur M. Sackler
Gallery, S2015.18

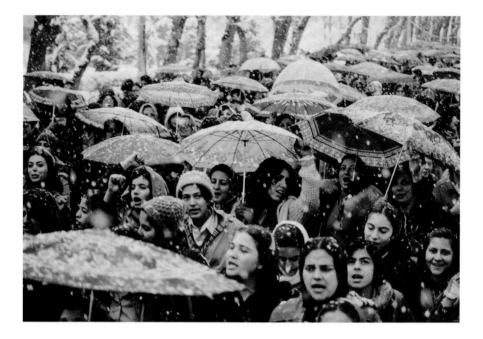

137
Untitled
From the series
Witness 1979
Hengameh Golestan
(b. 1952, Iran)
1979
Inkjet print,
30.1 × 45.2 cm
Purchase—
Jahangir and
Eleanor Amuzegar
Endowment for
Contemporary
Iranian Art
Arthur M. Sackler
Gallery, S2015.19

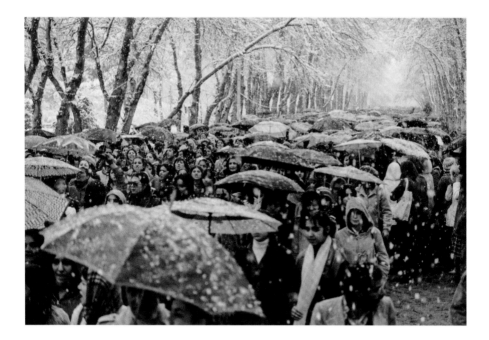

138
Untitled
From the series
Witness 1979
Hengameh Golestan
(b. 1952, Iran)
1979
Inkjet print,
30.1 × 45.2 cm
Purchase—
Jahangir and
Eleanor Amuzegar
Endowment for
Contemporary
Iranian Art
Arthur M. Sackler
Gallery, S2015.20

India

Documentary photography in the Freer|Sackler's collections takes a significant turn with a group of more than one hundred prints by **Raghubir Singh** (1942–1999) (figs. 139–51). Influenced by the work of such photographers as Henri Cartier-Bresson (1908–2004) and William Gedney (1932–1989), Singh is widely recognized for his dynamic compositions—and for shooting in color when black-and-white was the preferred style for established photographers. Traveling repeatedly throughout India for nearly three decades, he vividly rendered the rich spectrum of moods and encounters between traditional and modern in the flow of daily life.

Enchanted by his mother's stories of the Ganges, Singh photographed sites along the waterway during multiple trips between 1966 and 1990. From its source in the Himalayas, through Banaras (now Varanasi) to Bangladesh, he observed pilgrims and religious festivals, as well as mundane moments and changing landscapes along the great river's banks. Whether watching swimmers in the soft morning light of Varanasi, climbing snowy peaks, or catching reflections of wrestlers in dark waters, Singh conveys a profound respect for the enduring power of place.

The Ambassador car, a potent symbol of post-independence India, is the centerpiece of one of his last series, A Way into India. In production from 1957 until 2014, the ubiquitous "Amby" figures prominently in many of Singh's images. Framed by the car's rounded profile, fleeting moments, jarring reflections, and saturated colors offer a striking contrast to his Ganges series. Together, they demonstrate Singh's mastery of color photography and in representing the complexity of modern India.

139
Holy Man in a Palanquin, Kumbh Mela, Allahabad
Raghubir Singh
(India, 1942–1999)
1977
Chromogenic print,
50.8 × 40.6 cm
Gift of the artist
Arthur M. Sackler
Gallery, S1993.39.15

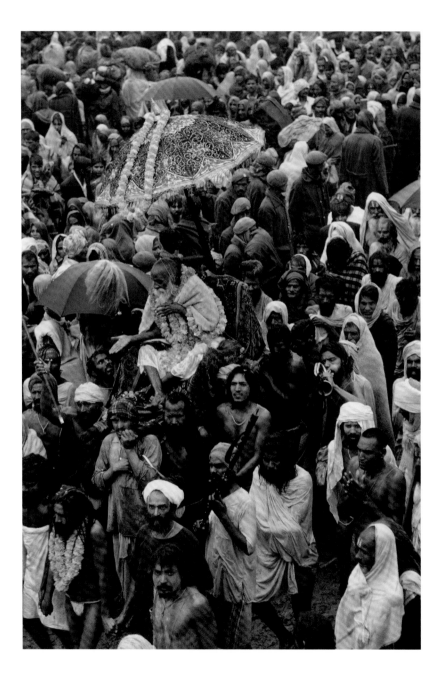

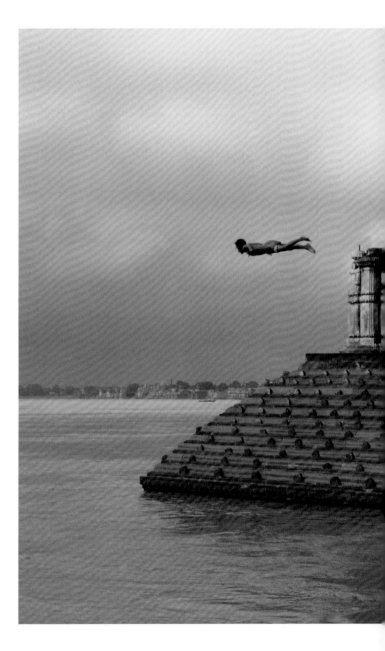

140
*Swimmers Dive from
Flood Submerged
Temples, Banaras*
Raghubir Singh
(India, 1942–1999)
1986
Chromogenic print,
40.6 × 50.8 cm
Gift of the artist
Arthur M. Sackler
Gallery, S1993.39.8

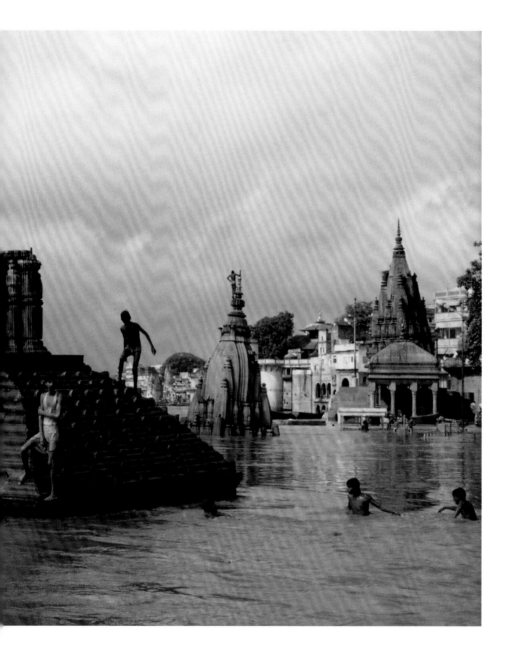

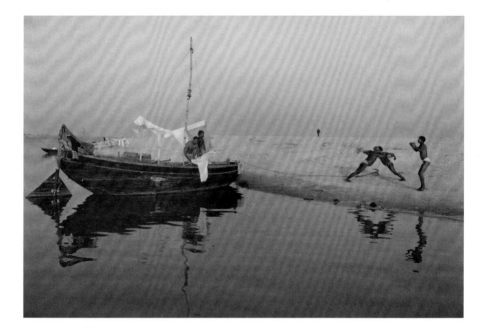

141
*Men Exercise on the
Sand Bank Facing
Banaras*
Raghubir Singh
(India, 1942–1999)
1986
Chromogenic print,
40.6 × 50.8 cm
Gift of the artist
Arthur M. Sackler
Gallery, S1993.39.9

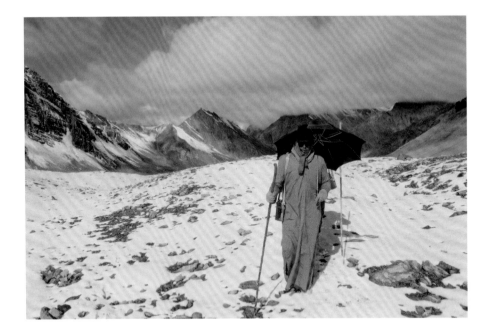

142
*Pilgrims to Kailas in
Tibet, Lipu Leh (Pass)*
Raghubir Singh
(India, 1942–1999)
1981
Chromogenic print,
40.6 × 50.8 cm
Gift of the artist
Arthur M. Sackler
Gallery, S1993.39.49

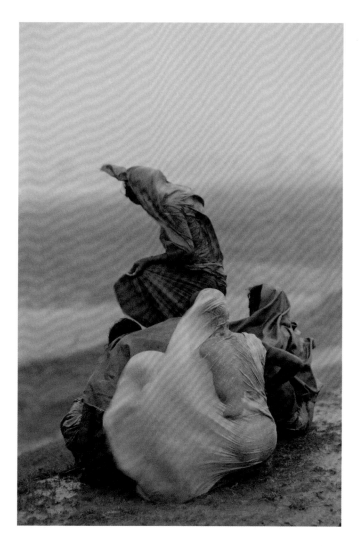

143
*Women Caught in
Monsoon Rains,
Monghyr, 1967*
Raghubir Singh
(India, 1942–1999)
1967
Chromogenic print,
50.8 × 40.6 cm
Gift of the artist
Arthur M. Sackler
Gallery, S1993.39.34

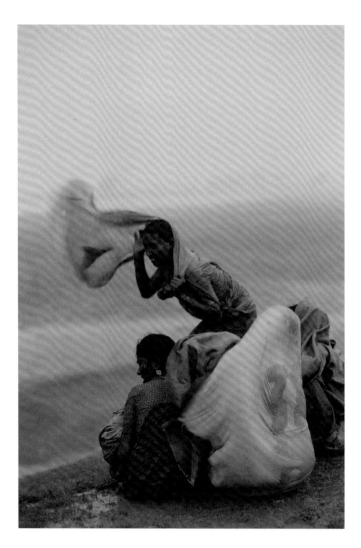

144
*Women Caught in
Monsoon Rains,
Monghyr, 1967*
Raghubir Singh
(India, 1942–1999)
1967
Chromogenic print,
50.8 × 40.6 cm
Gift of the artist
Arthur M. Sackler
Gallery, S1993.39.36

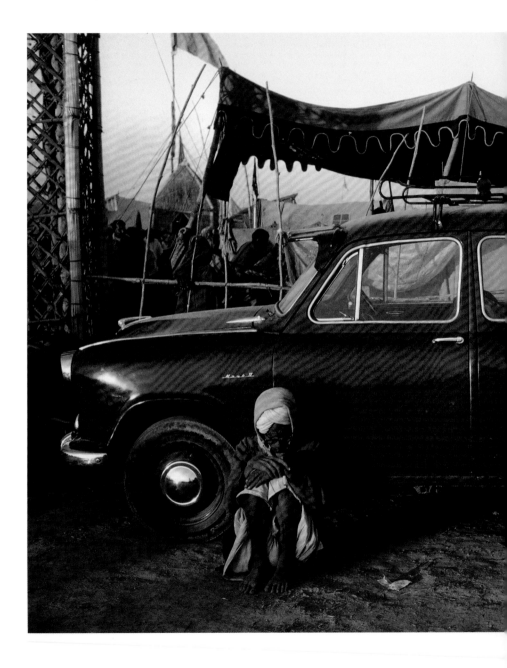

145
*Kumbh Mela,
Allahabad, Uttar
Pradesh*
Raghubir Singh
(India, 1942–1999)
1977
Digital photographic
print, 80 × 120 cm
Gift of the Estate of
Raghubir Singh
Arthur M. Sackler
Gallery, S2003.4.33

146
Howrah Bridge,
Calcutta, West Bengal
Raghubir Singh
(India, 1942–1999)
1987
Digital photographic
print, 50.8 × 61 cm
Gift of the Estate of
Raghubir Singh
Arthur M. Sackler
Gallery, S2003.4.46

147
Kerala
Raghubir Singh
(India, 1942–1999)
1998
Digital photographic
print, 50.8 × 61 cm
Gift of the Estate of
Raghubir Singh
Arthur M. Sackler
Gallery, S2003.4.20

148
Untitled
Raghubir Singh
(India, 1942–1999)
1998
Digital photographic
print, 50.8 × 61 cm
Gift of the Estate of
Raghubir Singh
Arthur M. Sackler
Gallery, S2003.4.1

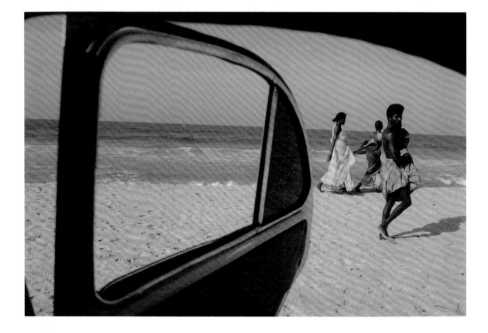

149
Rameshwaram, Tamil Nadu
Raghubir Singh
(India, 1942–1999)
1994
Digital photographic print, 80 × 120 cm
Gift of the Estate of Raghubir Singh
Arthur M. Sackler Gallery, S2003.4.15

150
*Pedestrians,
Firozabad, Uttar
Pradesh, 1992*
Raghubir Singh
(India, 1942–1999)
1992
Digital photographic
print, 50.8 × 61 cm
Gift of the Estate of
Raghubir Singh
Arthur M. Sackler
Gallery, S2003.4.47

151
Grand Trunk Road,
Durgapur, West Bengal
Raghubir Singh
(India, 1942–1999)
1998
Digital photographic
print, 50.8 × 61 cm
Gift of the Estate of
Raghubir Singh
Arthur M. Sackler
Gallery, S2003.4.43

Expanding the Collection

Moving beyond the museum's focus on Japan, Iran, and India, **Ahmed Mater** (born 1979) has keenly observed Saudi Arabia and the dramatic socioeconomic changes that are shaping it. Influenced by the work of mid-twentieth-century American social documentary and landscape photographers, Mater has been photographing across Saudi Arabia for nearly a decade. Since 2011, he has focused on Mecca in western Saudi Arabia for the series titled Desert of Pharan, referring to the ancient name for the area around the holy city. In sharp contrast to earlier images of Mecca, Mater captures disorienting views of a global city undergoing the largest transformation in its history.

Nature Morte takes us into the heart of the city and the new Makkah Royal Clock Tower complex, with its luxury hotels, shopping mall, and other amenities now dominating the skyline above the Great Mosque. The quiet comfort of a private hotel room foregrounds the image, while the main sanctuary and Kaaba, the center of Muslims' pilgrimage to Mecca, are bathed in a cold green light in the background. *From the Real to the Symbolic City* (fig. 153) presents a contrasting perspective of the city. Pushed to the outskirts, the dense neighborhoods and traditional architecture that have characterized Mecca for centuries disappear into a horizon obscured by heavy, gray haze. The Makkah Royal Clock Tower looms like a beacon in the distance. In both photographs, Mater sees a city that is increasingly divided between public and private, local and global. His framing becomes a frank commentary on how political, social, and economic pressures are reconfiguring the center of the Islamic world and questions the impact of such spatial changes on Saudi Arabian society.

From the streets of Tokyo and Tehran to the riverbanks of India and evolving city of Mecca, the museum's growing holdings offer glimpses into the development of photography in Asia from the late twentieth century to the present. As artists continue to experiment with the medium, create innovative formats, and grapple with a range of subjects, the Freer|Sackler will continue to broaden and deepen its representation of the rich and dynamic spectrum of contemporary Asian photography.

152
Nature Morte
From the series Desert
of Pharan
Ahmed Mater
(b. 1979, Saudi Arabia)
2013
Laserchrome print,
119.4 × 123.2 cm
Purchase—Friends of
the Freer and Sackler
Galleries
Arthur M. Sackler
Gallery, S2014.6

153
*From the Real to the
Symbolic City*
From the series Desert
of Pharan
Ahmed Mater
(b. 1979, Saudi Arabia)
2012
Laserchrome print,
200 × 165 cm
Purchase—Friends of
the Freer and Sackler
Galleries
Arthur M. Sackler
Gallery, S2014.5

Endnotes

1 Deepali Dewan, *Embellished Reality: Indian Painted Photographs*
 (Toronto: ROM Press, 2012).

2 Debra Diamond, "Occult Science and Bijapur's Yoginis," in *Indian Painting:
 Themes, History and Interpretations (Essays in Honour of B. N. Goswamy)*, ed.
 Mahesh Sharma (Ahmedabad: Mapin Publishing, 2013).

3 Shiva Balaghi and Anthony Shadid, "Nature Has No Culture: The Photo-
 graphs of Abbas Kiarostami," *Middle East Report*, no. 219 (summer 2001), 31.

4 Walker Evans, "The Reappearance of Photography," *Hound and Horn* 5, no. 1
 (October–December 1931), 125–28, as cited in Maria Morris Hambourg,
 "Atget, Precursor of Modern Documentary Photography," in *Observations:
 Essays on Documentary Photography*, ed. David Featherstone (Carmel:
 Friends of Photography, 1984), 35.

About the Authors

David Hogge has served as head of the Freer|Sackler Archives since 2001, guiding the department through its transition into the digital age. In particular, Hogge is working to give due visibility to the Archives' important collections of early photography of Asia. He received a master's degree in art history, with an Asian art emphasis, from the University of Washington in 1993.

Carol Huh, associate curator of contemporary Asian art, became the Freer|Sackler's first curator of contemporary art in 2007. Through exhibitions, acquisitions, and public programs, Huh focuses on current social change and artistic production related to Asia. Recent projects have included such exhibitions as *Symbolic Cities: The Work of Ahmed Mater*, the museum's ongoing *Perspectives* series (featuring works by Y.Z. Kami, Hale Tenger, Hai Bo, Rina Bannerjee, and Michael Joo, among others), and *Fiona Tan: Rise and Fall* (Vancouver Art Gallery), for which Huh was the in-house curator. She received bachelor's and master's degrees from Georgetown University.

Index

Al-Ani, Jananne, 10, 52; figs. 1, 43
Al-Ghoussein, Tarek, 10, 70; figs. 55–57
Amuzegar, Jahangir and Eleanor, Endowment for
 Contemporary Iranian Art, figs. 31, 32, 53, 54, 61,
 98–100, 131–38
Arni, Clare, 56; fig. 45

Beato, Antonio, 104; fig. 59
Beato, Felice, 9, 82, 92, 104; figs. 9, 64, 71, 72
Black, J. R., 22
Bourne, Samuel, 77; fig. 58
British East India Company, 80

Cameron, Julia Margaret, 84
Cartier-Bresson, Henri, 188
Chavannes, Edouard, 110
Cixi, Empress Dowager, 9, 28; figs. 20–24
Coburn, Alvin Langdon, fig. II
Conner, Lois, 78, 118; figs. 88, 89
Cyrus the Great, 138; fig. 105

Davis, Lynn, 78, 138; figs. 103, 104
Do-Ho, Suh, 10, 64; figs. 50–52

Evans, Walker, 149

Freer, Charles Lang, 1–2, 5, 77, 86, 88, 104, 106, 110,
 116, 118; figs. II, III, 84, 87
 and photography, 1–2, 77, 110, 116
Friends of the Freer and Sackler Galleries, figs. 3,
 44, 46–52, 55–57, 90–92, 108–29, 152, 153
Frith, Frances, 78, 96; figs. 73–75

Gedney, William, 188
Gerster, Georg, 78, 138; fig. 105
Ghadirian, Shadafarin, 10, 44; figs. 36–42
Gill, Gauri, 10, 58, 64; figs. 3, 46–49
Gojong, Emperor, 26
Golestan, Hengameh, 176–77; figs. 132–38

Hai Bo, 78, 120; figs. 90–92
Hamaguchi Takashi, 150–51; figs. 115–19
Herzfeld, Ernst, 2, 78, 101; figs. 60, 76–78
Hideko Fukushima, 150

Impey, Eugene Clutterbuck, 84; fig. 65

Jalali, Bahman, 10, 38, 44, 176; figs. 31, 32, 130
Javadi, Rana, 172; fig. 131
Japan Subjective Photography League, 150
Jikken Kobo, 150

Kiarostami, Abbas, 78, 134; figs. 101, 102
Kim Kyu-jin, 26; figs. 18, 19
Kitadai Shozo, 150; figs. 110–14
Khomeini, Ayatollah Ruhollah, 176, 177
Kurkdjian, Onnes, 88; fig. 70

Lê, An-My, 78, 124; figs. 93–97
Longworth, Alice Roosevelt, 22, 26; figs. 16–20

Maison Bonfils, 104; fig. 79
Maruki Riyō, 22; figs. 16, 17
Mater, Ahmed, 149, 204; figs. 109, 152, 153
Mohan Lal, 86; figs. 66, 67
Moriyama Daido, 151; figs. 120–24
Murray, John, 80; fig. 63

Nayiny, Malekeh, 10, 40; figs. 33–35, cover
Nasir al-Din Shah, 33; figs. 26, 29, 30

O'Keeffe, Georgia, 5
Otsuji Kiyoji, 150

Photographic Society of Bengal, 80, 84
photography, in China, 9, 28, 78, 110; figs. 20–24,
 82–92
 in Egypt, 77, 78, 96, 104; figs. 59, 73, 74, 79
 in India, 10, 12, 54, 56, 58, 77, 80, 82, 84, 149, 188,
 204; figs. 3–7, 44–49, 58, 62–67, 139–51
 in Iran, 9, 33, 38, 44, 68, 78, 101, 130, 134, 149,
 176–77, 204; figs. 2, 25–42, 53, 54, 60, 61, 76, 78,
 98–102, 130–38, cover
 in Iraq, 52, 101; figs. 1, 43, 77
 in Japan, 1, 2, 9, 12, 77, 92, 149, 150–52, 204;
 figs. I, 8–17, 71, 72, 106–108, 110–29
 in Java, 88; fig. 70
 in Jerusalem, 96; fig. 75
 in Korea, 26, 64; figs. 18, 19, 50–52

in Kuwait, 70; figs. 55–57
in Saudi Arabia, 149, 204; figs. 109, 152, 153
in Sri Lanka, 88; figs. 68, 69, frontispiece
in Syria, 106; figs. 80, 81, 103
in Vietnam, 78, 124; figs. 93–97
Provoke, 151
Pushpamala N., 10, 56; fig. 45

Renjō, Shimooka, 16, 22
Rhoades, Katharine Nash, 5; fig. IV
Robertson, James, 82
Rosin, Henry and Nancy, 2; Collection of Early
 Photography of Japan, figs. I, 9–15, 71

Sachtler, August, 9, 16; fig. 8
Samadian, Seifollah, 78, 130; figs. 61, 98–100
Schmidt, Erich, 138
Scowen and Co., 88; fig. 69, frontispiece
Sevruguin, Antoin, 2, 9, 33, 38, 176; figs. 2, 25–30
Singh, Pamela, 10, 54; fig. 44
Singh, Raghubir, 149, 188; figs. 139–51
Skeen and Co., 88; fig. 68
Steichen, Edward, 5; fig. III
Stieglitz, Alfred, 5; fig. IV
Stillfried, Raimon von, 92
Sugimoto Hiroshi, 78, 142; figs. 106, 107
Suzuki Shinichi, 9, 22; figs. 13–15, 17

Tabrizian, Mitra, 10, 68; figs. 53, 54
Taft, William Howard, 22, 26
Tripe, Linnaeus, 80; fig. 62
Tsuchida Hiromi, 151–52; figs. 108, 125–29

Whistler, James McNeill, 5

Xunling, 28; figs. 20–24

Yūtai, 110; figs. 82, 83, 85